IMAGES
of America

ESTES PARK

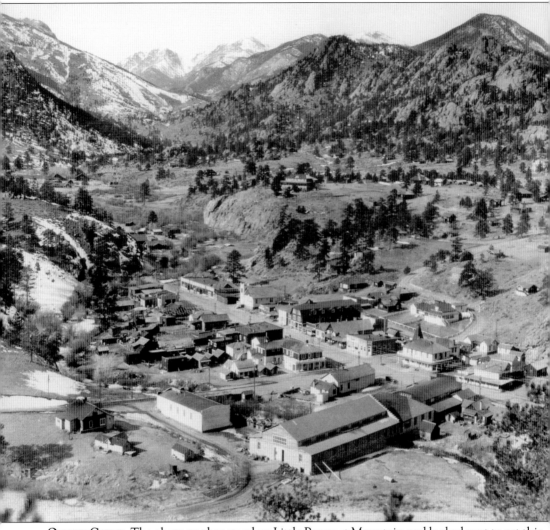

ON THE COVER: The photographer stood on Little Prospect Mountain and looked west to get this overview of the business district of Estes Park. Elkhorn Lodge is visible at the base of Old Man Mountain in the upper left corner, and the Lewiston Hotel is on the bluff above the community church in the middle of the photograph. The presence of automobile garages at the west edge of the street indicates that this image was produced in about 1921. (Courtesy of Estes Park Museum.)

IMAGES
of America
ESTES PARK

Sybil Barnes

ARCADIA
PUBLISHING

Published by Arcadia Publishing
Charleston SC, Chicago IL, Portsmouth NH, San Francisco CA

Printed in the United States of America

Library of Congress Control Number: 2009943768

For all general information contact Arcadia Publishing at:
Telephone 843-853-2070
Fax 843-853-0044
E-mail sales@arcadiapublishing.com
For customer service and orders:
Toll-Free 1-888-313-2665

Visit us on the Internet at www.arcadiapublishing.com

*To three wise women who have been mentors and guiding lights:
Lennie Bemiss, Lorna Knowlton, and Larae Essman.*

CONTENTS

ACKNOWLEDGMENTS

It is almost impossible to understand what brings people to the chronicling of history. It is definitely a community effort.

Primary thanks to my parents for leaving Iowa to make a life for themselves in the mountains of Colorado.

Lennie Bemiss, Ruth Deffenbaugh, and many volunteers created the local history index and the vertical file collection at the Estes Park Public Library in the early 1970s. Without their dedication and hard work, very little of the history of Estes Park would be so readily available. Current library staff members who are helpful include Kathleen Kase, Mark Riffle, Eric Srot, and Dan Kirkpatrick.

The Estes Park Area Historical Museum was established in 1964 as a repository for historical artifacts. Derek Fortini, current manager of the (renamed) Estes Park Museum, was generous with his time and computer expertise in making many of the photographs from the museum collection accessible for this project. Alicia Mittelman of the museum staff and volunteer Marshall Hesler also gave freely of their time and expertise.

Lulie and Jack Melton gave invaluable help with photographs from their personal collections and the collection of the Lula Dorsey Museum at the YMCA of the Rockies. In addition, I would like to thank them for the years of friendship and encouragement that we have shared since Lulie and I first met as children at a square dance or hymn sing at the "Y Camp."

Individuals who contributed images and information include Betsy and Art Anderson, May Anderson, E. R. "Andy" Anderson, Will Citta, Linda Elmarr of the Stanley Museum, Byron Hall, Susan Harris, Bobbie Heisterkamp, Ken Jessen, Steve Mitchell, Laura Beth Miller, Jody Magnuson, Ann Pettit Fuller Morrow, Duke Sumonia, and Jean Weaver.

Jim Pickering has done the heavy lifting of producing the most recent wave of comprehensive histories of the area. You will find some of his publications listed in the bibliography.

John Meissner of the Estes Park History Rescue Project and Estes Park Archives has been an inspiration for his contributions to establishing accurate image dates and bringing local history programs to the community. His dedication encourages all of us to keep the flame of collecting and sharing historical information burning brightly.

Thanks also to Devon Weston, Jerry Roberts, and the production staff of Arcadia Publishing.

INTRODUCTION

The high mountain valley that now contains the village of Estes Park, Colorado, was first seen by a prospector and hunter named Joel Estes who had come to Colorado as a result of the discovery of gold at Pikes Peak in 1859. He thought it was so beautiful that he brought his family to live here for several years. The Estes family moved on in 1866.

Many others followed including Irish aristocracy, English authors, Scots and Welsh homesteaders, newspaper publishers, nature enthusiasts, movie stars, entrepreneurs, peak baggers, and a wide variety of ordinary and extraordinary people looking for a place to relax and enjoy the outdoors or start a business or raise a family.

In 1905, a plat was laid out for the downtown, and enterprising realtors began to sell property. Soon after, Enos Mills and members of the Colorado Mountain Club began a campaign to preserve the wilderness west of the village as a national park. Congress signed the enabling act to create Rocky Mountain National Park in 1915.

The town of Estes Park was incorporated in 1917. The downtown business area included the main intersection of Elkhorn and Moraine Avenues with approximately three blocks of shops and houses and a community gathering area, designated as a park.

This book contains a selection of photographs that reflect my personal memories of some of my favorite places. As you look at them, notice the natural features that ring our town. These include the massive peaks of the Continental Divide, the distinctive "thumb" on Prospect Mountain, and the rock formations of Lumpy Ridge, such as the Twin Owls and the Little Mummy. While the buildings changed from 1905 through 1985, these physical features remain the same and keep you oriented to how the town sits on the land.

History is what happens to us every day. If you have visited or lived in Estes Park, I hope you will find an open door to memories of your own.

One

Growth of a Town

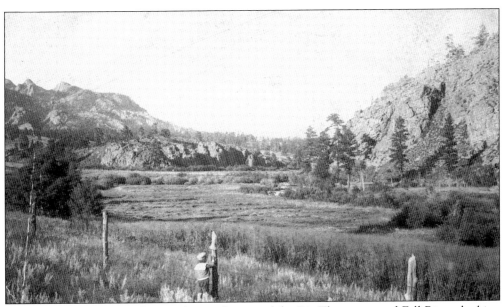

An unidentified boy stands near the confluence of the Big Thompson and Fall Rivers looking east. Lumpy Ridge is to the north behind the cliff that overshadows the road visible in the middle left, which led to MacGregor Ranch. The MacGregors homesteaded on Black Canyon Creek in 1873. (Courtesy of Estes Park Museum.)

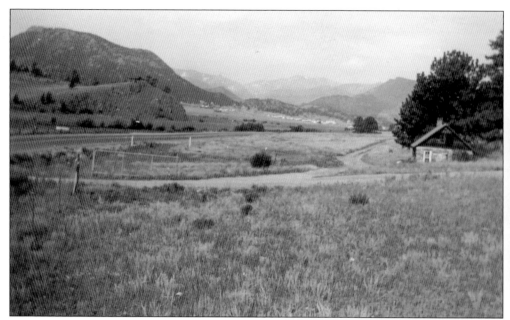

This is the view a tourist coming from Loveland would have seen after rounding the final curve of the Big Thompson Road in the early part of the 20th century. Prospect Mountain is to the left, and the bluff visible in the left middle ground will serve as the southern anchor of the Lake Estes Dam. (Courtesy of Estes Park Museum.)

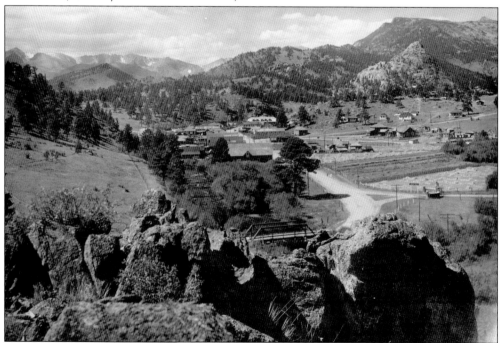

The other eastern approach to Estes Park was from Lyons. This image from approximately 1916 shows a glimpse of the Front Range to the left and Old Man Mountain in the middle ground on the right. The bridge crosses the Big Thompson River, and the gate to the Stanley Hotel property is visible to the right. (Courtesy of Estes Park Museum.)

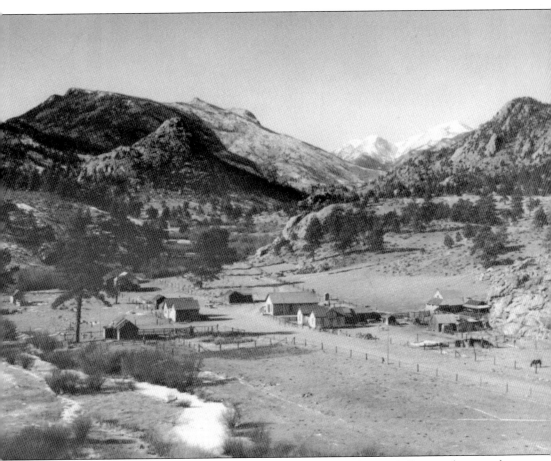

Here is downtown Estes Park in 1903. The identified buildings in this H. C. Rogers photograph are W. T. Parke's photography studio, under the tree and close to the river for access to water; the post office and general store on the south (left) side of Elkhorn Avenue; the first church and schoolhouse directly across the street; and John Cleave's home, also on the north (right) side. Cleave homesteaded the area and built the schoolhouse in 1888. It subsequently served as a theater, dance hall, and meeting space for the Odd Fellows fraternal organization, and was eventually used as a store. (Courtesy of Estes Park Museum.)

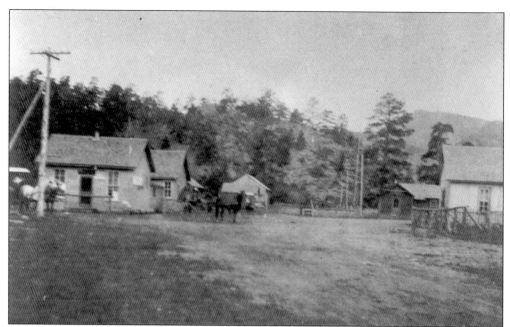

This is a closer view of the post office and general store constructed by John Cleave. The schoolhouse is the white building across the street. John Cleave was a carpenter who came to Estes Park to work on the construction of the English Hotel on Fish Creek Road. (Courtesy of Estes Park Museum.)

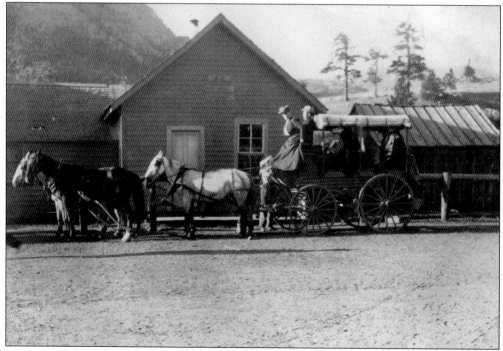

It is hard to tell from this 1902 photograph whether the stage is arriving at or departing from Cleave's store. The mail also arrived from Lyons once a day. Prospect Mountain and Davis Hill are visible in the background. (Courtesy of Estes Park Museum.)

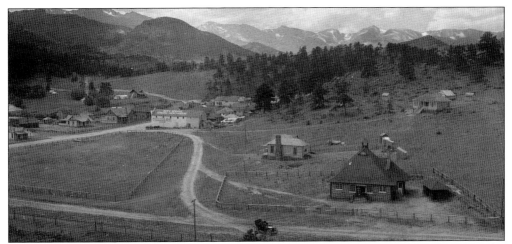

This 1906 image by Denver photographer Louis McClure shows the new schoolhouse in the foreground. Longs Peak and the peaks of the Continental Divide rise in the background. The road in the foreground leads to the MacGregor Ranch. In the middle of the photograph is Samuel Service General Store. A consortium headed by C. H. Bond purchased Cleave's homestead acreage and platted the future town with commercial and residential lots that they began to sell in 1905. The open space across from the real estate office was designated as a park "for all to enjoy." (Courtesy of Lula W. Dorsey Museum, YMCA of the Rockies.)

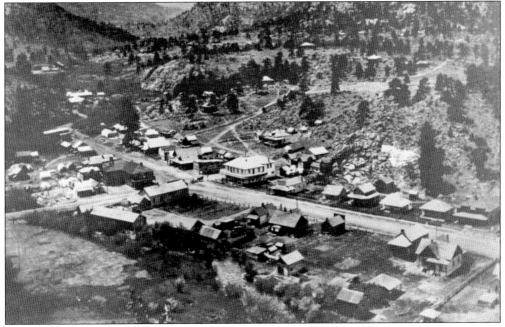

By 1908, a great deal of change is evident at the intersection of Moraine and Elkhorn Avenues. Cleave's store on the southwest corner has been replaced by the Hupp Hotel and a rival hotel, the Manford House, has risen on the northeast corner across from the new brick building that houses the Estes Park Bank. The bank and much of the infrastructure of the fledgling town are funded by F. O. Stanley, one of the inventors of the Stanley steam car. W. T. Parke has moved his studio to a store to the east of the Manford House, where he can sell images and curios directly to visitors. (Courtesy of Estes Park Museum.)

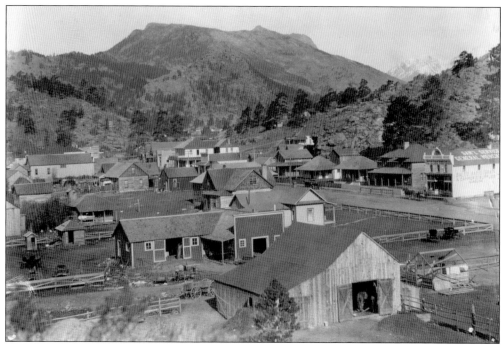

Horses are still the main mode of transportation in 1908, so barns and blacksmith shops are part of the downtown scene. The general store, which Sam Service has operated since 1901, is directly east of the Service home on the north side of Elkhorn Avenue. (Courtesy of Estes Park Museum.)

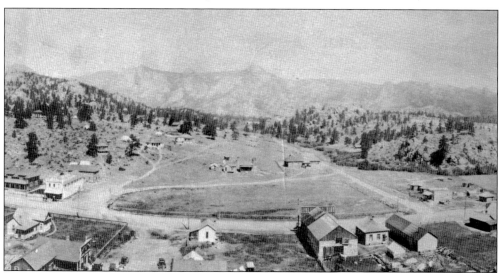

The Twin Owls on Lumpy Ridge are hazily visible to the right in the background of this 1909 view of Bond Park. Sam Service has added an awning to his store. The house across the street belongs to the Boyds, who now have a sign identifying their blacksmith shop in the lower left foreground. (Courtesy of Estes Park Museum.)

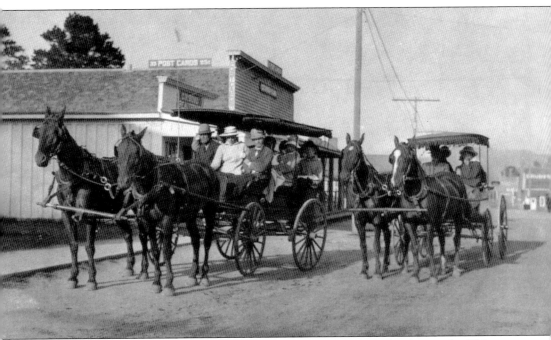

Two carriages full of visitors are about to set out for a drive. They may be heading to the Elkhorn Lodge for a meal, or they may be taking a tour of the town with the realtor C. H. Bond. (Courtesy of Estes Park Museum.)

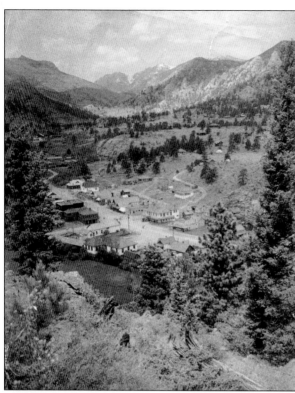

Perched on the shoulder of Little Prospect Mountain, a Denver photographer captured the intimate mountain setting of Estes Park in about 1911. The two main hotels dominate the intersection. The new Community Church of the Rockies is visible on the north side of the street past the Estes Park Bank and Fred Clatworthy's store, which includes the renovated first schoolhouse building. Behind the bank is a secondary street, which will eventually be named for John Cleave. (Courtesy of Estes Park Museum.)

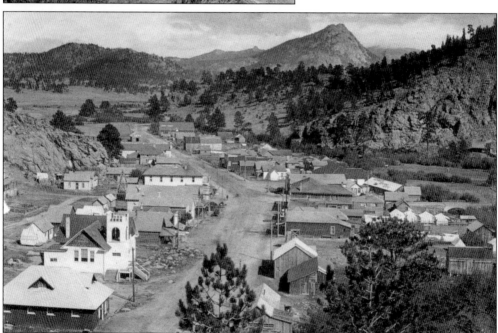

This photograph is from the west end of the downtown area and clearly shows the new church. Many of the early settlers in Estes Park have Scottish and/or English heritage, and the prevailing denomination is Presbyterian. The bridge visible on Moraine Avenue goes across the Fall River. (Courtesy of Estes Park Museum.)

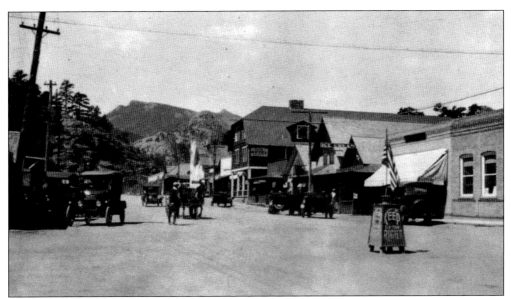

As cars begin to replace horse-drawn vehicles, a need arises for street signage. This is the corner of Elkhorn and Moraine Avenues in 1915. The Estes Park Bank anchors the corner with the Clatworthy shops and a new hotel, the Brown Tea Pot Inn, farther west. (Courtesy of Estes Park Museum.)

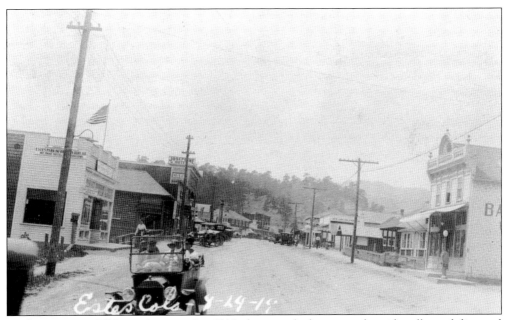

Looking west on Elkhorn Avenue, this 1919 photograph shows wooden sidewalks and diagonal parking on the still unpaved street. Another hotel, the Josephine, was built in 1916. Josephine Hupp was one of the many enterprising women who formed the core of business owners in early Estes Park. This image also shows the overhangs that were popular on many buildings. They provided additional living space on the second floors as well as offering shelter for shoppers who might be surprised by the afternoon rains that commonly occur in summer. (Courtesy of Estes Park Museum.)

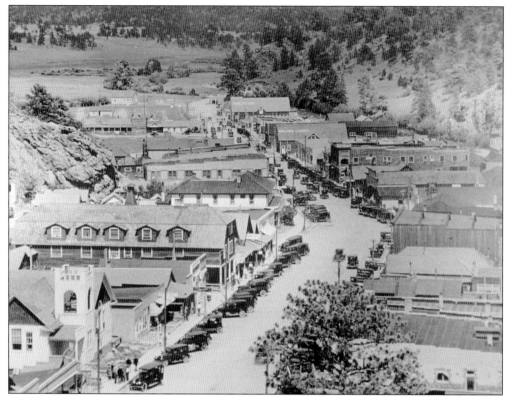

Though there are still livery stables on Elkhorn Avenue, cars are becoming the transportation of choice. This photograph from about 1923 shows the Sherwood Hotel on the left. Farther east, past the Hupp Hotel, the new National Park Hotel is almost directly across the street from the Josephine. Many of the cars appear to be individual sedans, while in the middle right of this image one can see the touring buses of the Rocky Mountain Parks Transportation Company, whose garage and offices are a few doors east of the intersection of Elkhorn and Moraine Avenues. (Courtesy of Estes Park Museum.)

This promotional image shows young women in their outing gear. They have walked up the side of Little Prospect above the confluence of Fall River and the Big Thompson River. The large building in the foreground is the garage for the Rocky Mountain Parks Transportation Company. Visible in the background is the new Lewiston Hotel, constructed in 1915. With its view of the village and Longs Peak, it rivals the Stanley as the place to stay. Many locals also patronize its restaurant and attend dances and other events there. (Courtesy of Estes Park Museum.)

18

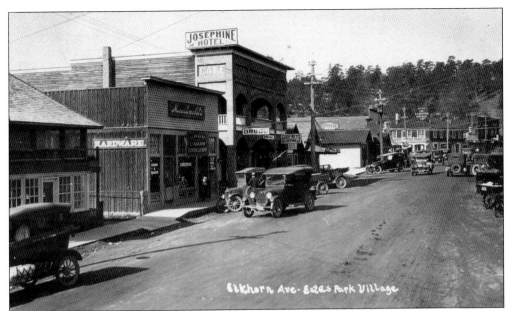

This is another view of the Josephine Hotel. Next door to the east is Macdonald's general store, which offered necessities from hardware to groceries. The building to the east of that is the Macdonald home. At the corner of Elkhorn and Moraine Avenues, the first Hupp Hotel is now a part of a group of hotels managed by A. D. Lewis, who has constructed the luxurious Lewiston in town and the Lewiston Chalets near Mary's Lake. Directly west of the Josephine is the Tallant Confectionery. R. H. "Judge" Tallant is a noted painter, whose wife manages this café. (Courtesy of Lulie and Jack Melton.)

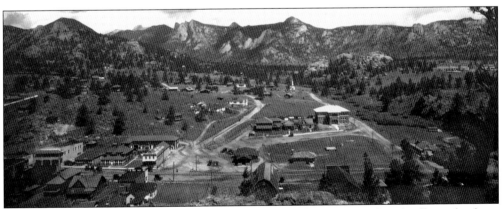

This image shows changes to Bond Park that occurred in the early 1920s. The schoolhouse has been expanded, and buildings next to it include the Presbyterian manse and the Prospect Inn. Visible behind them is the spire of St. Walters Church. A growing number of Catholics are among the visitors, and a local family offered to renovate their home to provide a space for worship services. The Stanley Hotel is visible to the far right. The library is in the middle of Bond Park. Directly to the west is the post office and town hall. The National Park Hotel is farther to the west at the left edge of this view. (Courtesy of Lula W. Dorsey Museum, YMCA of the Rockies.)

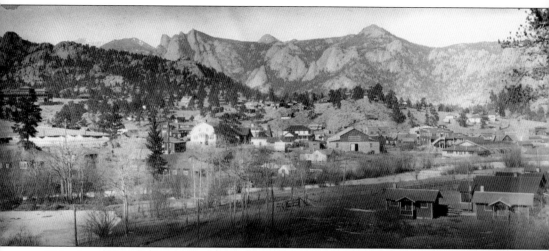

This view of the Big Thompson River and Riverside Drive shows the back of buildings along the south side of Elkhorn Avenue. The small cabins in the right foreground were probably rentals. (Courtesy of Lula W. Dorsey Museum, YMCA of the Rockies.)

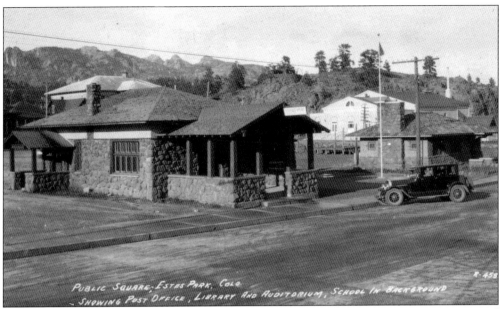

This postcard shows the buildings in Bond Park. The post office and the library were constructed of native stone. The large white structure in the background is the auditorium. On the ridge above it are the ruins of a cabin, constructed for Al Birch, which burned in 1908. (Courtesy of Estes Park Museum.)

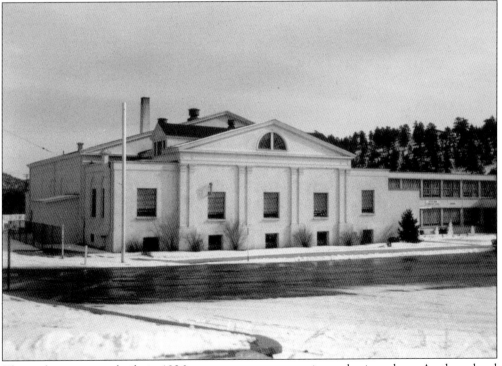

The auditorium was built in 1926 to serve as a community gathering place. As the school population increased, some classes were held there. The high school addition was constructed in 1939. (Courtesy of Estes Park Museum.)

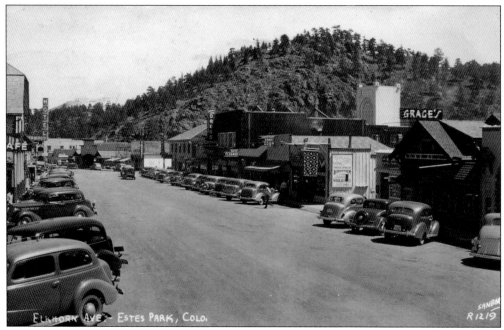

This Sanborn postcard shows a mix of tourist stores and the kind of services any small town offers in about 1938. C. E. Grace was a pioneer photographer who sold film, postcards, and souvenirs. (Courtesy of Lulie and Jack Melton.)

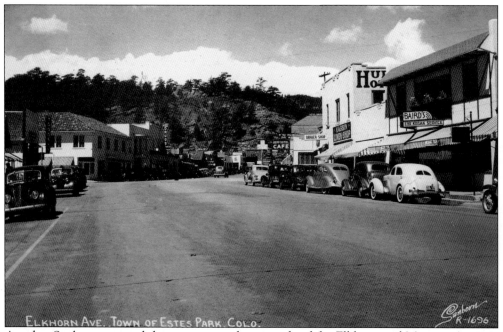

Another Sanborn postcard shows stores on the east side of the Elkhorn and Moraine Avenues intersection. (Courtesy of Lulie and Jack Melton.)

This photograph gives an overview of the size of the town limits of Estes Park in the early 1930s. The large hotel in the foreground is the Crags, built on the side of Prospect Mountain by Joe Mills. From this vantage point he could see his competitors, the Stanley to the east and the Lewiston to the west. (Courtesy of Estes Park Museum.)

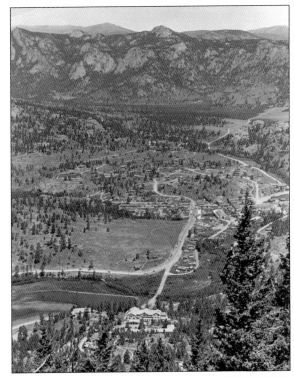

The approach to Estes Park from the east offers a panoramic view of the peaks of the Continental Divide. (Courtesy of Estes Park Museum.)

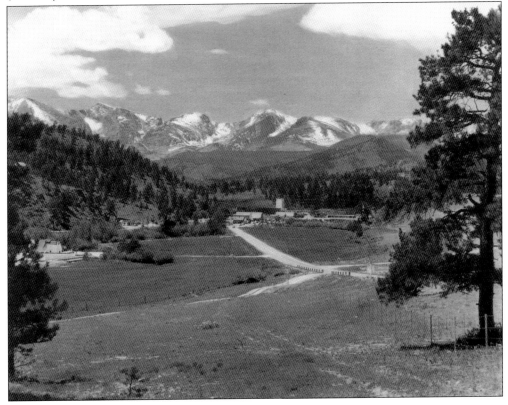

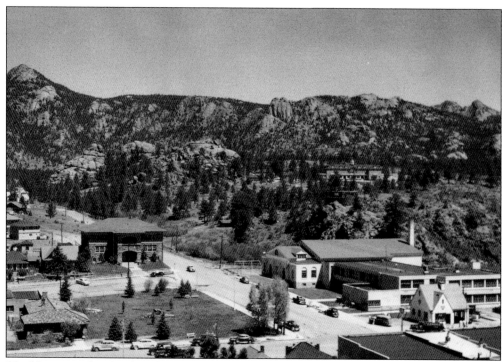

The library, grade school, and high school surround Bond Park in this photograph from the late 1940s. (Courtesy of Estes Park Museum.)

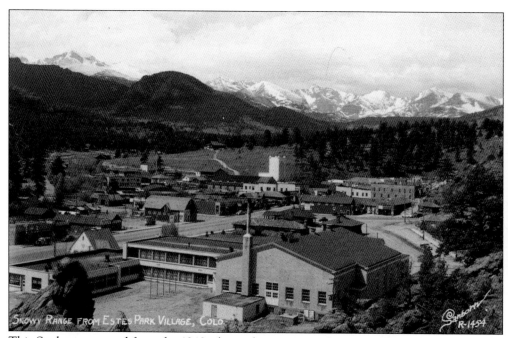

This Sanborn postcard from the 1940s shows the remaining livery on Elkhorn Avenue on the corner of Elkhorn Avenue and Riverside Drive. (Courtesy of Lulie and Jack Melton.)

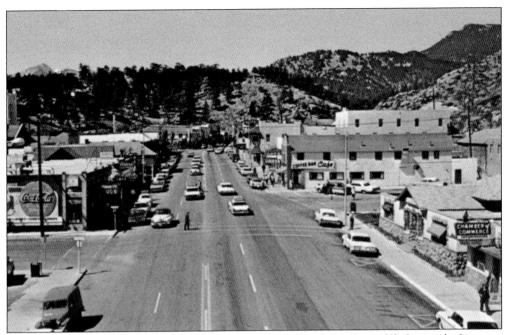

The streets have been paved, and the west end of Bond Park has been filled in with the town hall and chamber of commerce buildings in this postcard from the late 1950s. The shops include a drug store, a liquor store, and several small cafes. The Hupp Hotel and National Park Hotel are still accepting guests but the Josephine lost its second story in a fire and has been converted into a bar. (Courtesy of Lulie and Jack Melton.)

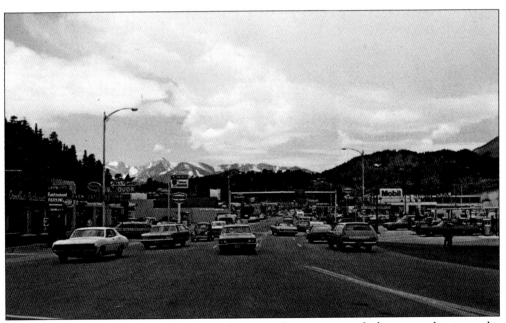

At the east end of Elkhorn in the 1960s, the car and its necessary fueling stops dominate the landscape. (Courtesy of Lulie and Jack Melton.)

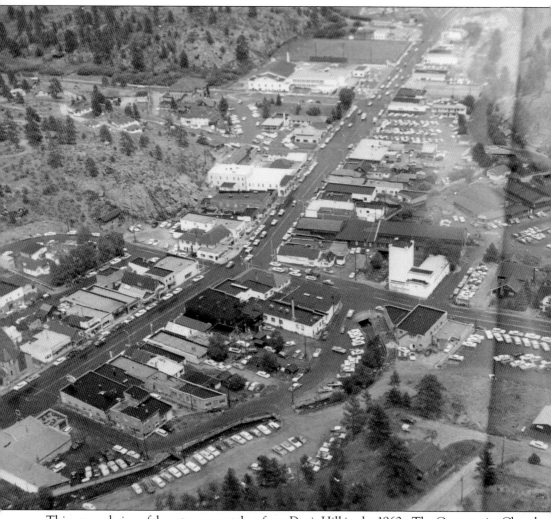

This unusual view of downtown was taken from Davis Hill in the 1960s. The Community Church of the Rockies is at the far left. The high school football field is visible at the top center. (Courtesy of Estes Park Museum.)

Two

Colorado Big Thompson Project

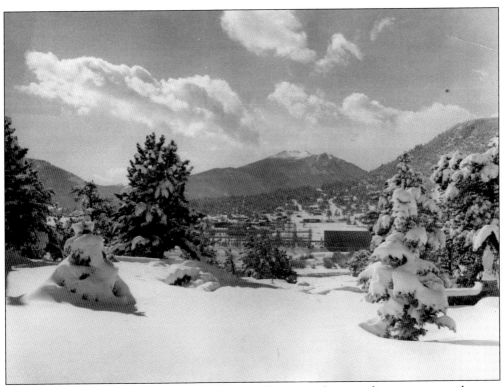

The Estes Power Plant is visible from Highway 34. It is part of a water diversion project that was approved in the late 1930s. Water is pumped and gravity-fed through a 13.1-mile tunnel under the Continental Divide to a series of reservoirs throughout Larimer, Boulder, and Weld Counties. (Courtesy of Estes Park Museum.)

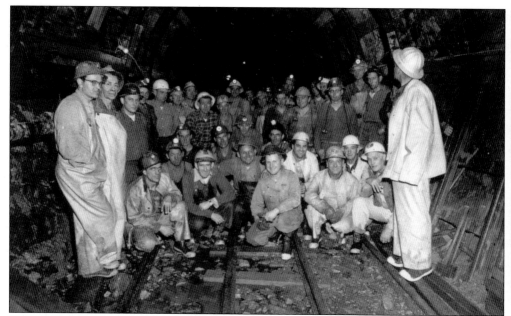

Planning and engineering for the Colorado Big Thompson project started in 1935. The east-side crew who worked on the Adams Tunnel was employed by the S. S. Magoffin Company. Construction started in 1940 and involved 1,800,000 man-hours of labor. This project brought an influx of year-round residents to Estes Park. (Courtesy Estes Park Museum.)

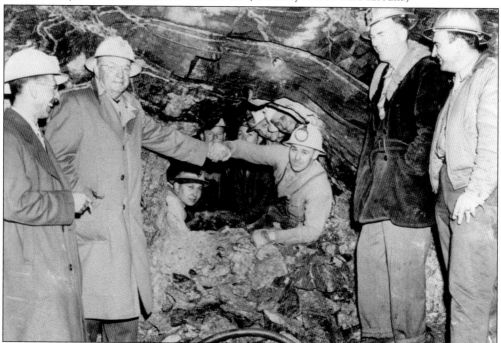

Crews worked drilling and blasting from both sides of the Continental Divide. The engineering was so precise that after 8 miles from the East Portal and 5.1 miles from the West Portal, the final blast exposed a difference of seven-sixteenths of an inch. This photograph was taken on June 10, 1944. (Courtesy of Estes Park Museum.)

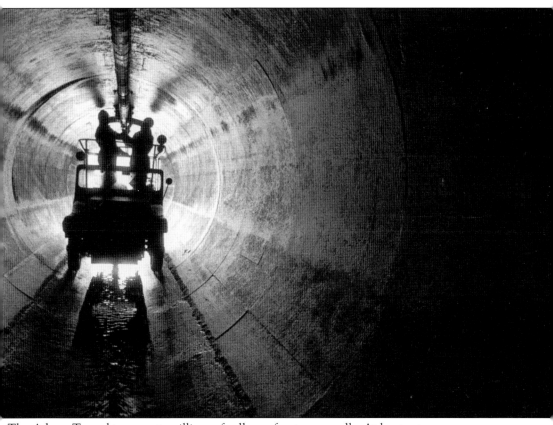

The Adams Tunnel transports millions of gallons of water annually. At least once a year, a crew drives a jeep through to check for maintenance issues. (Courtesy of Estes Park Museum.)

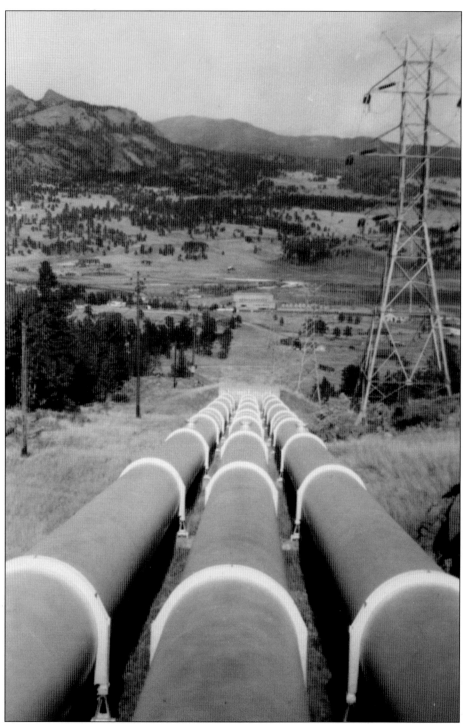

The East Portal of the Adams Tunnel is located 4 miles west of town past the YMCA of the Rockies. From there, the water goes through the Rams Horn tunnel to Marys Lake and then into another tunnel through Prospect Mountain. The final descent is through these penstocks on the east side of Prospect Mountain above Lake Estes. (Courtesy of Estes Park Museum.)

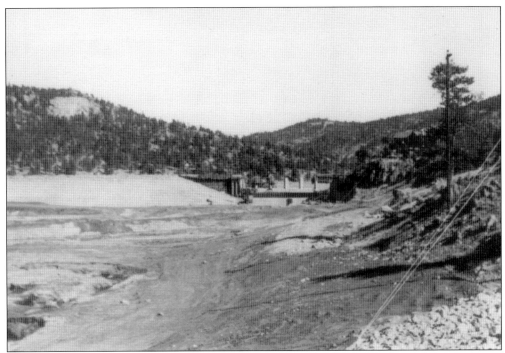

The site for Lake Estes was partially chosen for the natural bluff that forms the southern abutment. The sandstone house to the right in this photograph was built for Dr. Jacob Mall. (Courtesy of Estes Park Museum.)

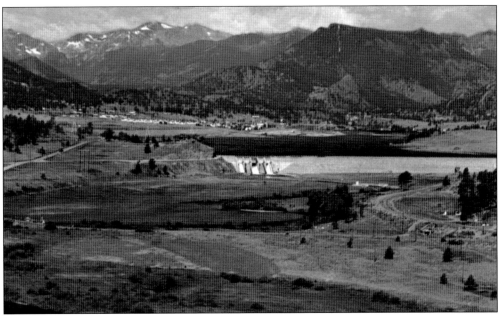

This postcard shows the completed Lake Estes Dam. The lake is 1 mile long and retains 2,700 acre-feet of water. (Courtesy of Lulie and Jack Melton.)

The influx of workers to complete the Colorado Big Thompson Project required additional housing, which almost doubled the population of Estes Park. The Bureau of Reclamation built these houses at the eastern edge of town in close proximity to the lake and the power plant. (Courtesy of Estes Park Museum.)

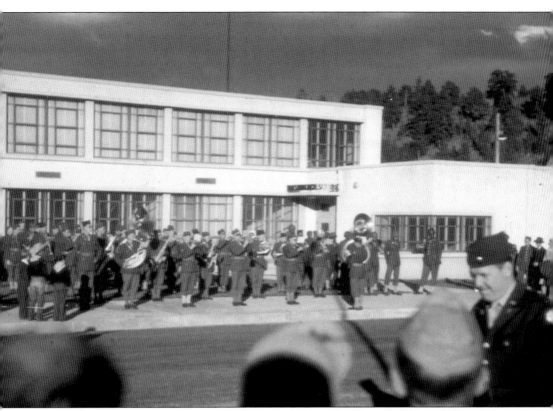

In celebration of the completion of the Adams Tunnel, this army band paraded through downtown in June 1944. (Courtesy of the Estes Park Museum.)

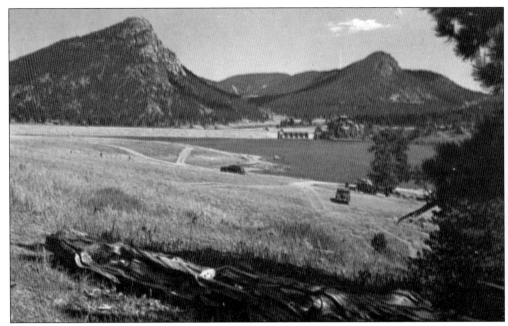

The completion of Lake Estes created new opportunities for recreation. (Courtesy of Lulie and Jack Melton.)

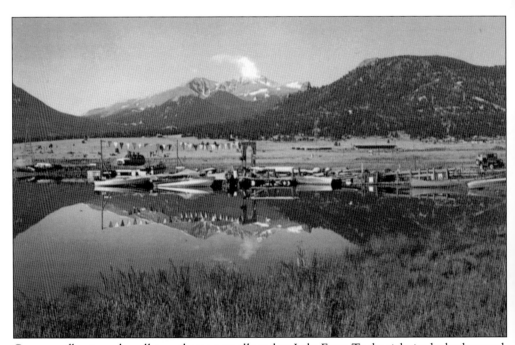

Canoes, sailboats, and small powerboats were allowed on Lake Estes. To the right in the background, the penstocks of the Prospect Tunnel are barely visible. The grandstand and barns at Stanley Park are also visible. (Courtesy of Lulie and Jack Melton.)

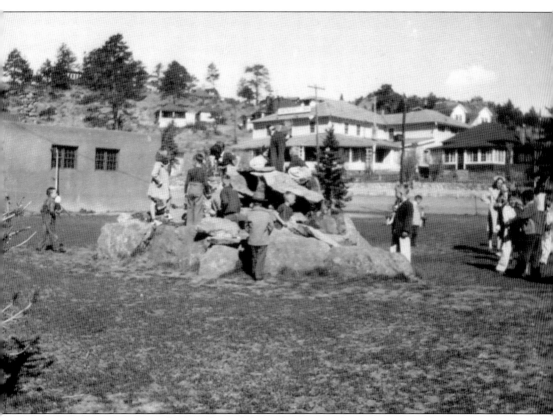

A commemorative fountain, which replicated the Adams Tunnel, was constructed in Bond Park. The park was also used as a playground by schoolchildren. The jail is shown in the background at left. (Courtesy of Estes Park Museum.)

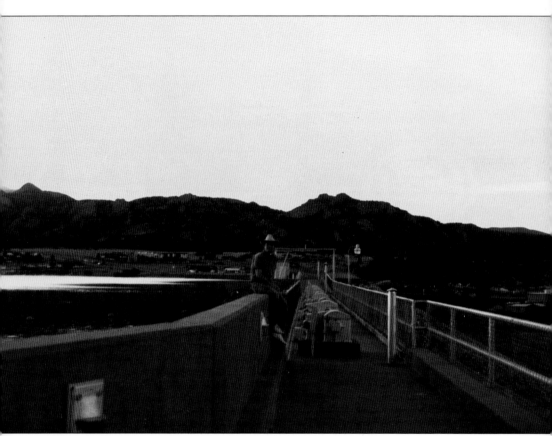

The Lake Estes Dam was a popular spot for fishing or as a front row seat for watching the fireworks on the Fourth of July. The crest of the dam stretches 1,951 feet and is 70 feet high. (Courtesy of Will Citta.)

Three

SERVICES AND BUSINESSES

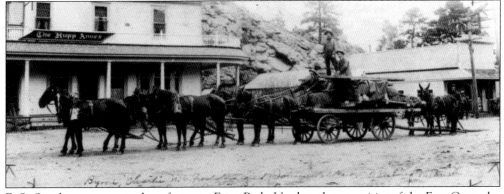

F. O. Stanley was a major benefactor to Estes Park. Used to the amenities of the East Coast, he wanted electricity for his new hotel and contributed a major portion of the funds necessary to build a power plant on the Fall River. This photograph shows the crew bringing equipment through town in 1908. (Courtesy of Byron Hall.)

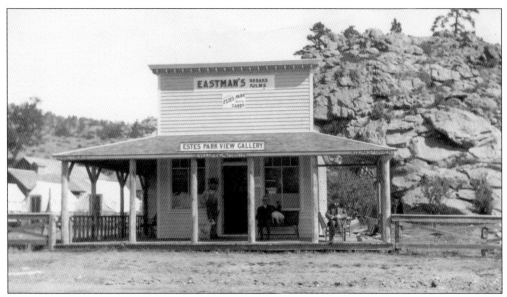

Photographs were coveted as souvenirs. W. T. Parke was one of the earliest entrepreneurs to sell views that he had captured as well as offering film for the do-it-yourselfer. His shop on Elkhorn Avenue was east of the Hupp Hotel. Also visible are tent cabins. Less expensive than a hotel room, they offered a wooden floor and canvas walls. (Courtesy of Estes Park Museum.)

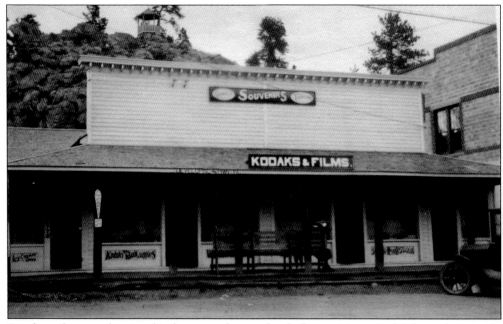

Snacks and treats of various kinds are another staple of sales to visitors. In this later photograph, Parke's store has expanded. (Courtesy of Estes Park Museum.)

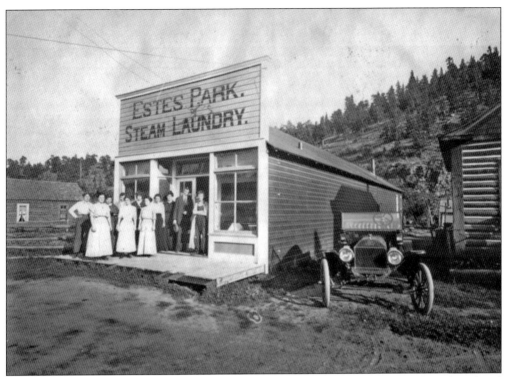

The staff of the Estes Park Laundry is ready for another day of handling everything from hotel linens to personal clothing. (Courtesy of Estes Park Museum.)

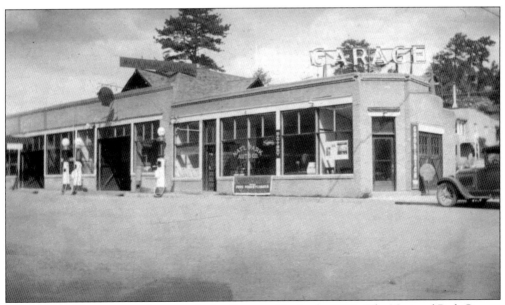

Garages and filling stations began replacing livery stables in the 1920s. The National Park Garage was at the west end of Elkhorn, near the church. (Courtesy of Byron Hall.)

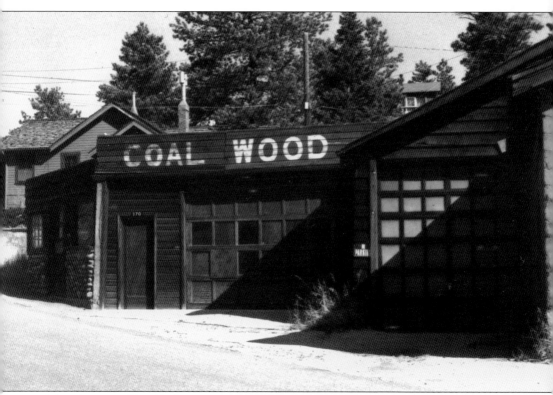

Many homes in Estes Park were summer-only cabins, but there was a need for fuel including coal, firewood, propane, and kerosene. This building also provided storage for ice that was cut from the streams and lakes in winter and packed in sawdust for use in the summer. (Courtesy of Estes Park Museum.)

Fred Payne Clatworthy was a nationally recognized photographer who established a home and several businesses. In addition to his own photographs and souvenirs, he sold snacks. The building on the left is the original schoolhouse constructed by John Cleave. (Courtesy of Lula W. Dorsey Museum, YMCA of the Rockies.)

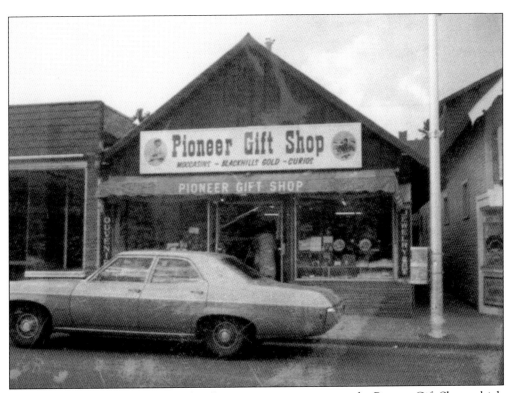

This 1969 photograph shows the schoolhouse in its incarnation as the Pioneer Gift Shop, which was operated by the Frumess family. (Courtesy of Estes Park Museum.)

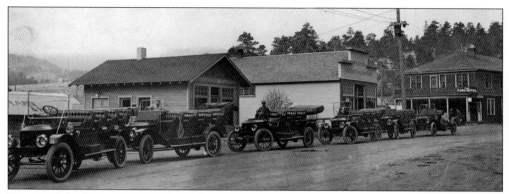

Few people had private cars in the early years of the 20th century. Summer visitors took the train from Midwestern cities and were driven to Estes Park in vehicles belonging to the transportation company. This photograph shows a fleet preparing to leave for Lyons or Loveland in about 1912. (Courtesy of Lula W. Dorsey Museum, YMCA of the Rockies.)

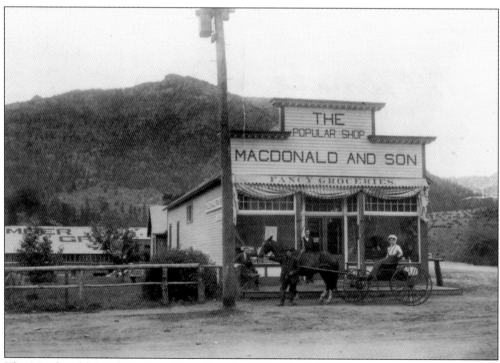

The Macdonald family came to Estes Park in 1908. One of their earliest enterprises was this grocery store. (Courtesy of Estes Park Museum.)

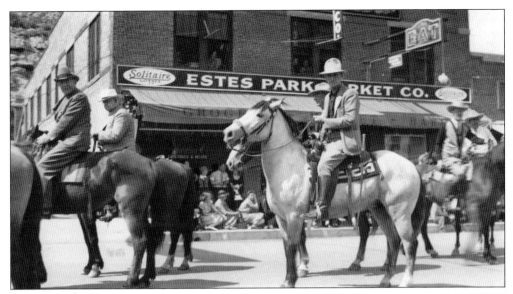

Fay Brainard was a Denver schoolteacher who spent his summers selling groceries in Estes Park. (Courtesy of Byron Hall.)

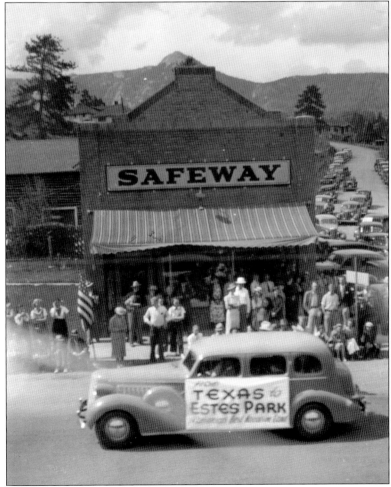

By 1938, the general store that had been owned by Sam Service was converted to a Safeway grocery store. (Courtesy of Estes Park Museum.)

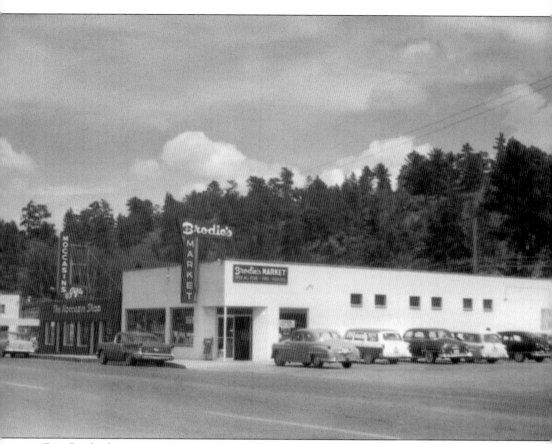

Ron Brodie first came to Estes Park in 1931 to work at the Honor Brite grocery in the former Sam Service building. In 1936, he and his brother Chet bought the Boyd store, which was in the block west of the Estes Park Bank. He celebrated the grand opening of this new store on East Elkhorn Avenue in August 1957. It was the "most modern grocery store in Northern Colorado" with an in-store bakery, a butcher counter, wide aisles, and the latest in check-out counters and carts. They also offered delivery service and store charge accounts. (Courtesy of Estes Park Museum.)

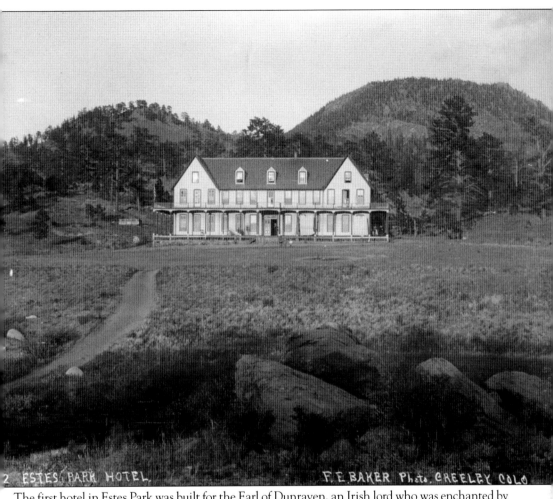

The first hotel in Estes Park was built for the Earl of Dunraven, an Irish lord who was enchanted by the scenery and the abundance of trophy animals to hunt in the area. Located on Fish Creek Road, it was finished in 1877 and burned to the ground in 1911. (Courtesy of Estes Park Museum.)

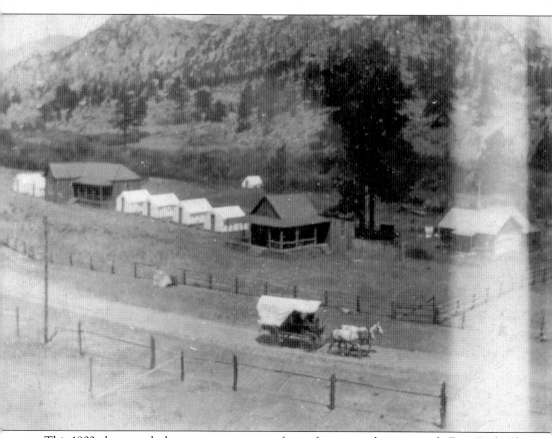

This 1902 photograph shows a more common form of accommodation in early Estes Park. These are the tent cabins on the property of Elizabeth Mary Ann Foot. Miss Foot also operated a store on Elkhorn Avenue. When the chamber of commerce put out an appeal for a building in the 1950s, she donated the funds. (Courtesy of Estes Park Museum.)

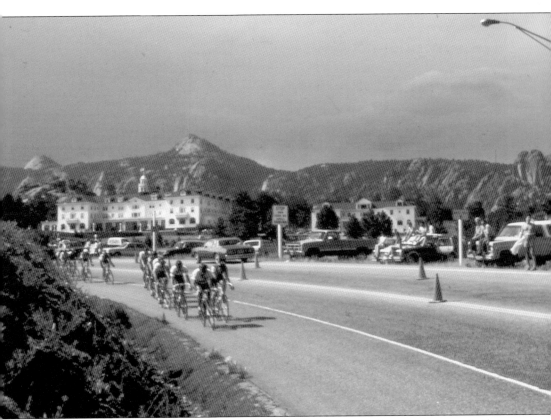

The Stanley Hotel is one of the most recognizable landmarks in the Estes area. It was built in 1909. This photograph was taken by Mike Vogel during the Coors Classic Bicycle Race. (Courtesy of Estes Park Museum.)

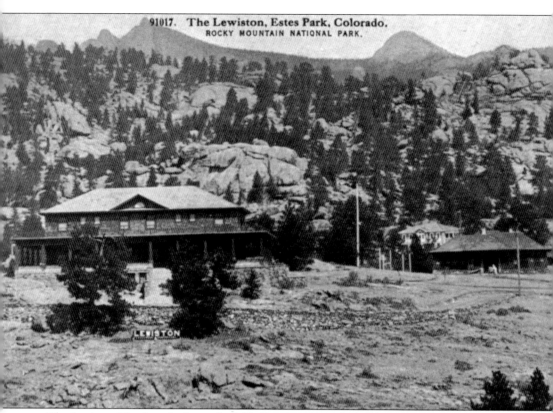

91017. The Lewiston, Estes Park, Colorado.
ROCKY MOUNTAIN NATIONAL PARK.

The Lewiston Hotel was built on a high bluff at the west end of Elkhorn Avenue. It was slightly more rustic than the Stanley but offered the same amenities—hot and cold running water, electric lights, telephone service, and a highly praised dining room. (Courtesy of Lulie and Jack Melton.)

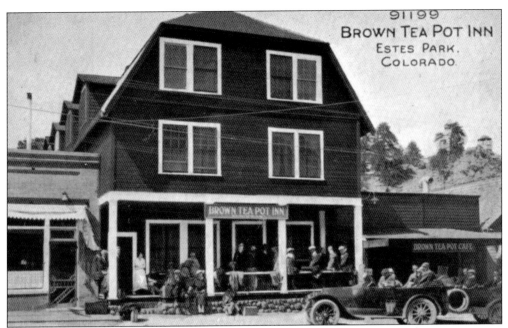

This postcard shows the Brown Tea Pot Inn, which was a popular hotel on west Elkhorn Avenue from 1915 to 1919. For one or two summers, it was owned by a group of Nebraskans who operated as the AkSarBen (which is Nebraska spelled backwards.) In 1921, it was renamed the Sherwood. (Courtesy of Lulie and Jack Melton.)

The Sherwood Hotel was destroyed by fire in 1956 and replaced by this modern building that housed two service businesses. (Courtesy of Estes Park Museum.)

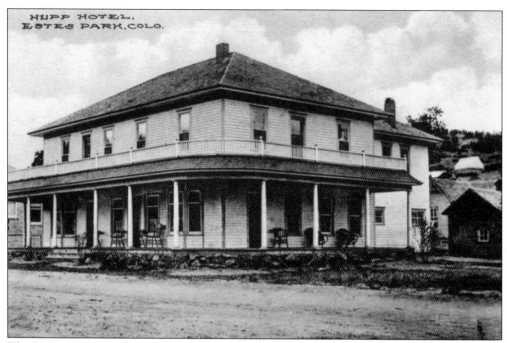

The Hupp Hotel on the corner of Elkhorn and Moraine Avenues was the first hotel in the downtown area. (Courtesy of Lulie and Jack Melton.)

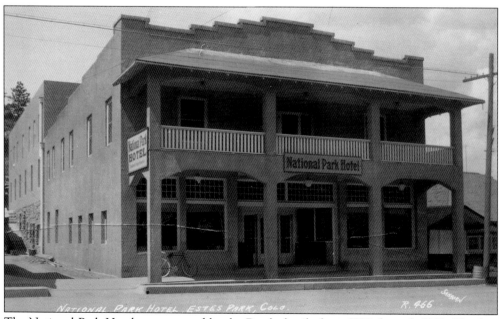

The National Park Hotel was operated by the Byerly family from 1920 through 1973. The first floor housed a popular restaurant, the Pine Cone Inn. The second-story veranda was a favorite spot for people watching. (Courtesy of Lulie and Jack Melton.)

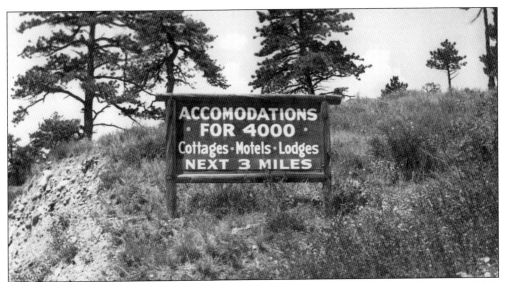

In 1963, this sign on the Moraine Park Road advertised the kinds of accommodations available to visitors. (Courtesy of Estes Park Museum.)

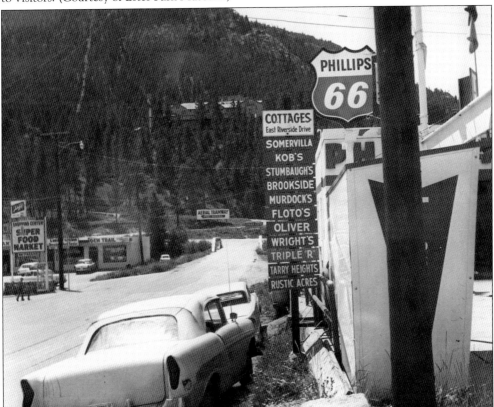

At the corner of Moraine Avenue and Crags Drive, this sign lists the cottages for rent. Many of them, such as Brookside and Triple R, offered kitchen facilities in addition to sleeping rooms. Some of them, such as Murdock's, also began to cater to visitors in the newly popular camping trailers or recreational vehicles. (Courtesy of Estes Park Museum.)

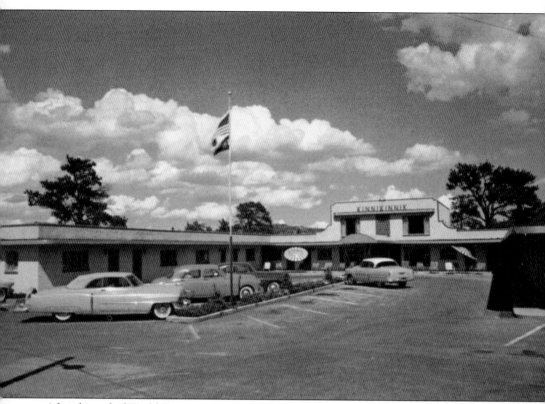

After the end of World War II, more people had the leisure time and disposable income to travel by car. The new style of accommodation was called a motel—short for motor hotel—where you could drive up and park in front of your room. The Kinnikinnik Motel, first of its kind in Estes Park, opened on the South Saint Vrain Highway in 1948. Karl and Ruth Wise advertised "innerspring mattresses, central hot water heat, and all tile baths." (Courtesy of Lulie and Jack Melton.)

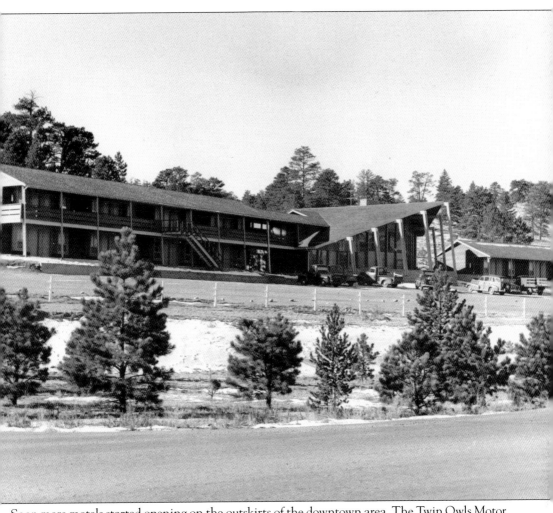

Soon more motels started opening on the outskirts of the downtown area. The Twin Owls Motor Lodge offered views of Lake Estes and Lumpy Ridge from its location on the corner of Highway 66 and Stanley Avenue in 1954. (Courtesy of Estes Park Museum.)

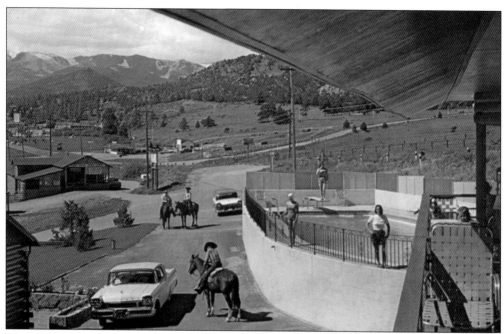

The Hobby Horse Lodge combined elements of the traditional dude ranch vacation with the amenities of the modern hotel. Located just east of downtown on Highway 34, accommodations ranged from motel rooms to log cabins. Guests could enjoy the outdoor swimming pool or ride a horse. (Courtesy of Lulie and Jack Melton.)

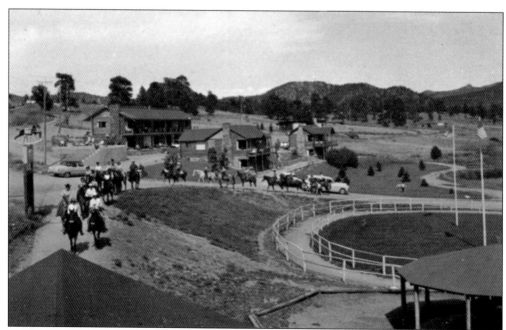

Trail rides from the Hobby Horse could meander along the shore of Lake Estes or cross the highway to access the trails of the north end that led towards Devils Gulch. Children could ride in a supervised pony ring. (Courtesy of Lulie and Jack Melton.)

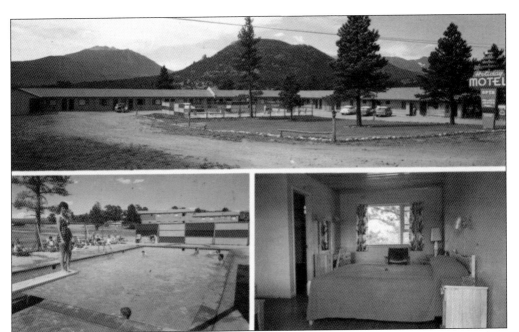

The Holiday Motel was farther east on the Big Thompson highway. It also offered an outdoor "heated" swimming pool and rooms furnished in contemporary style for the late 1950s. (Courtesy of Lulie and Jack Melton.)

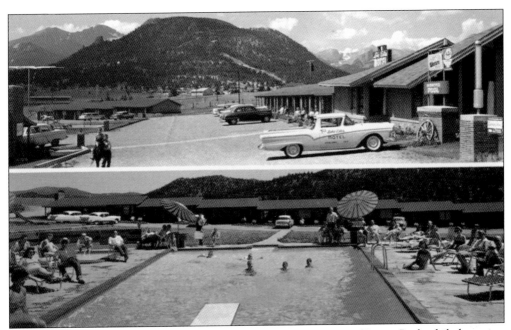

The Lake Estes Motel opened in 1963. Guests could enjoy a view of Longs Peak while lounging poolside. It was also the first motel visitors saw as they emerged from the Big Thompson Canyon. Its owner Lou Canaiy served on the state tourism board and brought many new ideas to the accommodation owners of Estes Park. (Courtesy of Lulie and Jack Melton.)

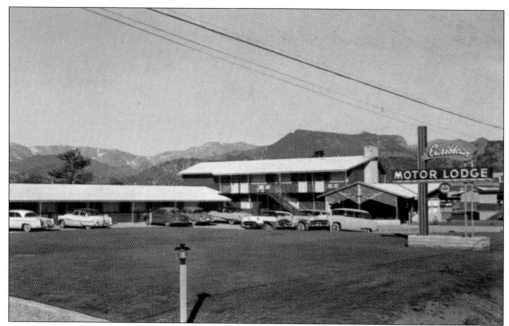

The Caribbean Motor Lodge opened in 1957, offering a panoramic view of the Continental Divide from its Highway 34 location. (Courtesy of Lulie and Jack Melton.)

As the number of travelers increased through the 1970s, the Caribbean added more rooms and a swimming pool and changed its name. (Courtesy of Lulie and Jack Melton.)

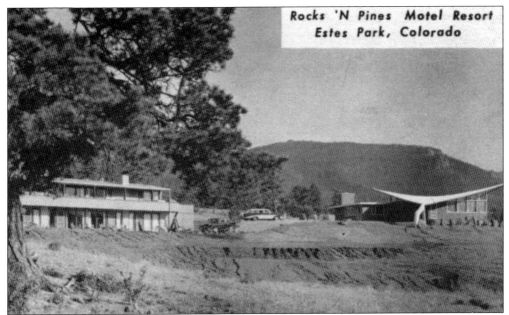

The town of Estes Park is named for Joel and Patsy Estes who are believed to be the first white family to live in the area. Near the site of their property on Fish Creek Road, this motel with its futuristic dining room was built in 1958. The motel was later renamed the Landmark because of its proximity to the stone monument that commemorates the Estes family. (Courtesy of Lulie and Jack Melton.)

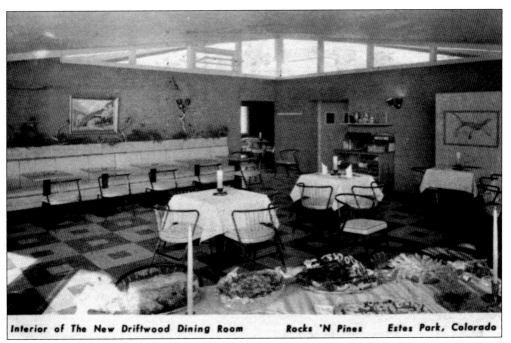

Under the swooping roof, the Driftwood Dining Room at the Rocks 'n Pines resort offered contemporary furnishings and traditional food. The views of Lake Estes and Longs Peak added to diners' enjoyment. (Courtesy of Lulie and Jack Melton.)

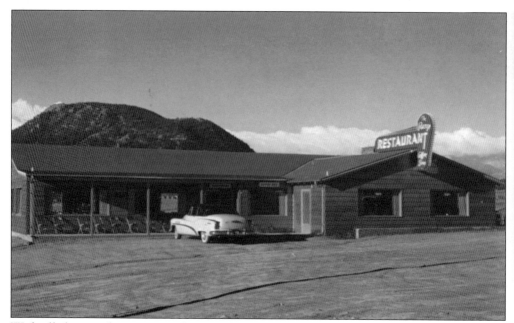

With all the motels sprouting along Highway 34, people saw the need for restaurants. The Range Restaurant was one of the first to open near the Lake Estes Motel. (Courtesy of Lulie and Jack Melton.)

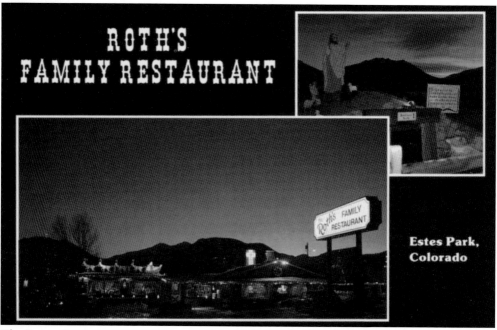

The Range Restaurant was purchased by the Roth family. They brought family recipes for fried chicken and other home-style foods that were extremely popular. This postcard shows the restaurant decorated for Christmas. The manger scene and some of the other ornaments had been purchased from the estate of a gentleman who consistently won the holiday lighting contest. (Courtesy of Lulie and Jack Melton.)

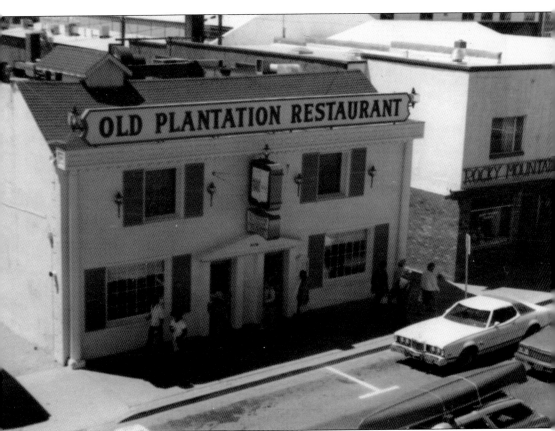

There were choices for restaurants downtown as well. The former Tallant Confectionery was purchased by Thelma Chapman in 1935. Her sons Bill and Bob Burgess served full meals and incredible pie. They maintained a collection of Tallant paintings for decoration. Waitresses at the Old Plantation were dressed in pinafores and mobcaps. The Ships Tavern on the second floor was a popular gathering spot for downtown merchants. (Courtesy of Estes Park Museum.)

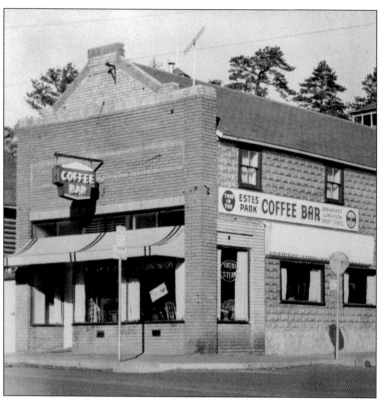

This former grocery store was converted into a dining room in 1948. Rooms upstairs housed the staff. Proximity to Bond Park and town hall made it a popular spot for town officials and downtown business owners. (Courtesy of Estes Park Museum.)

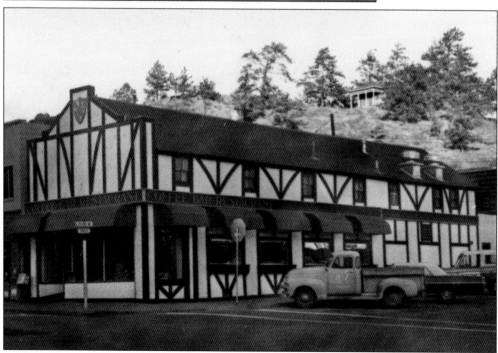

This 1975 photograph shows the Coffee Bar changing to reflect the times. (Courtesy of Estes Park Museum.)

Part of the charm of businesses in Estes Park is how some maintain a rustic facade. This postcard shows Cook's Log Cabin Cafe, a fixture on West Elkhorn Avenue beginning in the late 1920s. Fried chicken was a staple of the dinner menu. The "Log Cabin" became a waffle shop in later years. (Courtesy of Lulie and Jack Melton.)

COOK'S LOG CABIN CAFE, ESTES PARK, COLO.

THE MOST PICTURESQUE CAFE IN THE NATIONAL PARK. 108836

Theme restaurants were a popular trend. Located across from Bond Park, the Glockenspiel opened in 1970 with an Austrian theme and menu. This restaurant had formerly been the Tender Steer. In that incarnation, a baron of beef in the window lured diners. (Courtesy of Estes Park Museum.)

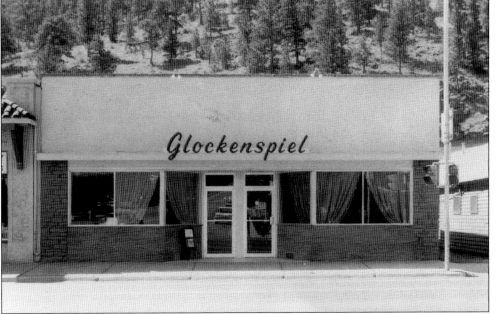

Glockenspiel

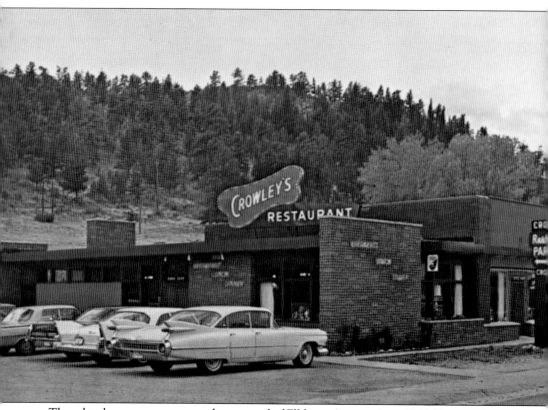

There has been a restaurant at the east end of Elkhorn Avenue since 1940. First on this site was the Ginger Blue Drive-In with a menu of sandwiches and malts. The space was subsequently the Trouthaven Café, and then Monty's Restaurant, before it was leased by Joe and Harold Crowley in 1961. Crowley's remained a favorite spot for breakfast, lunch, and dinner until 1978. (Courtesy of Lulie and Jack Melton.)

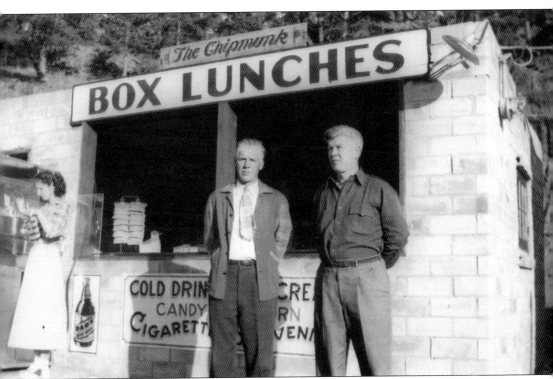

Many local residents opened summer businesses as a way to create supplemental income. The Chipmunk Box Lunch operated at the east end of Elkhorn Avenue as a "take-away" snack bar in 1948 and 1949. Pictured are Margie Markley at the popcorn machine, her husband Merle, and his brother Don Markley. They catered to people who wanted to take a picnic lunch into the national park. They also sold cigarettes and souvenirs. (Courtesy of Jody Magnuson.)

After fire destroyed the second floor of the Josephine Hotel, the street level was converted to a pool hall that served beer. This business evolved into the Wheel Bar, owned by the Nagl family since the late 1940s. (Courtesy of Estes Park Museum.)

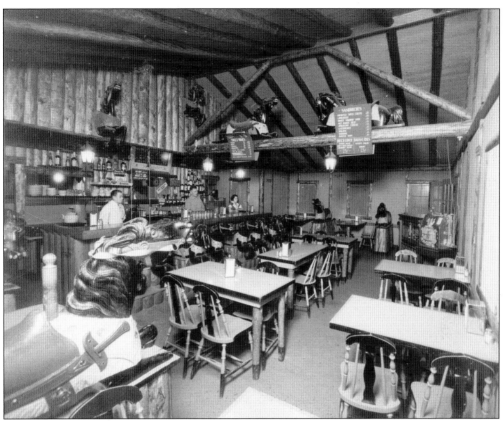

One of the most popular bars in town was the Dark Horse, which opened as a part of the Riverside Amusement Park complex in 1933. The bar stools and booth dividers were carousel horses, and the bar also served a limited sandwich menu. (Courtesy of Estes Park Museum.)

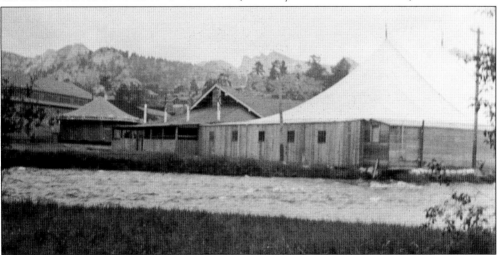

This view of the Riverside complex from about 1925 shows the dance hall and covered swimming pool with the Big Thompson River in front. The transportation company garage is visible in the background past the tent originally planned to house the carousel. (Courtesy of Estes Park Museum.)

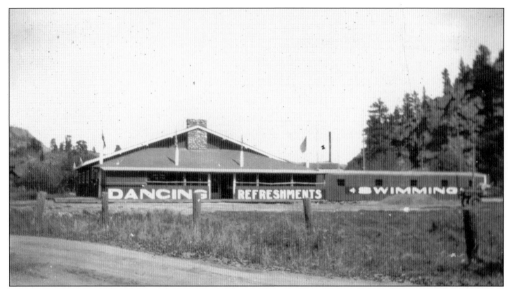

The main entrance to the Riverside complex was from Elkhorn Avenue via an alley between the Macdonald building and the Josephine Hotel. On summer nights, visitors strolling down Elkhorn Avenue could hear the sounds of big bands. The swimming pool was added to provide daytime recreation. (Courtesy of Estes Park Museum.)

This 1970 photograph of the Riverside complex buildings shows the Dark Horse Bar to the far left. The swimming pool was converted to a theater in the 1950s. The Dark Horse Players offered melodrama and classics such as *Uncle Tom's Cabin*. (Courtesy of Estes Park Museum.)

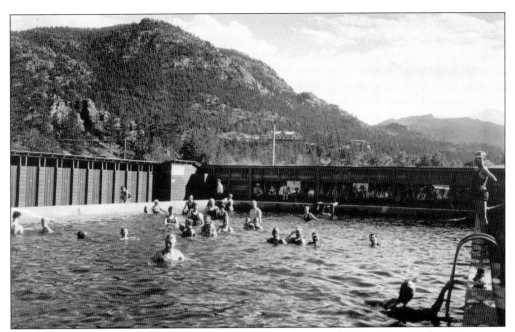

The pool at the Riverside was surrounded on three sides by lockers, a women's changing room, and an observation deck. Visible on the side of Prospect Mountain is the Crags Lodge. Swimmers could also see Longs Peak from the pool. (Courtesy of Estes Park Museum.)

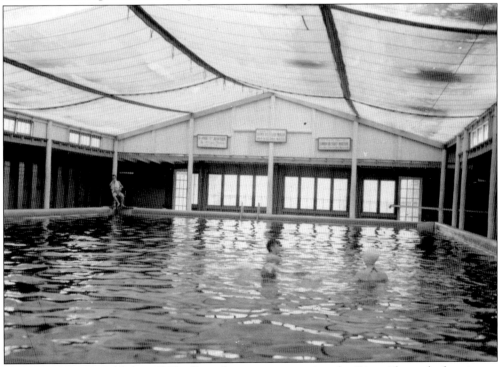

The canvas cover, added in 1925, allowed swimmers to enjoy the Riverside pool when it was raining or chilly outside. The water was heated by steam and maintained by a gravity filter. The pool depth ran to 7 feet. (Courtesy of Estes Park Museum.)

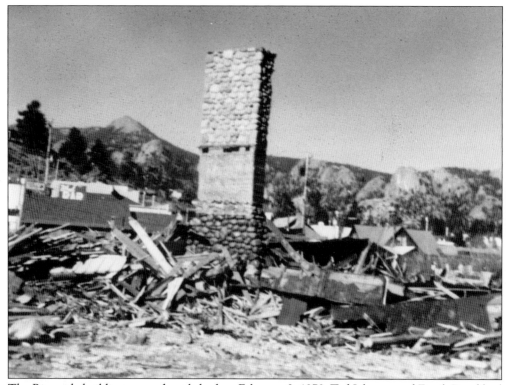

The Riverside buildings were demolished on February 2, 1970. Ted Jelsema and Frank Bond had opened the complex in May 1923. The dance floor, which could hold up to 200 couples, had been used as a miniature golf course in later years. The sounds of big bands such as the Nebraskans, the Romancers, Hub Else and the KU Jayhawks, and the Dean Bushnell Orchestra were silenced. Other memories of the Riverside include novelty dances, square dances, and community events such as the Panhellenic Ball and the Firemans Ball. (Courtesy of Estes Park Museum.)

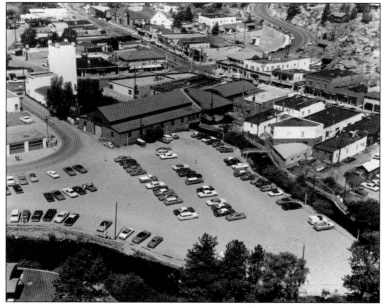

By the summer of 1970, a municipal parking lot obliterated all traces of the Riverside Amusement Park. (Courtesy of Estes Park Museum.)

Looking through the front window of the former National Park Hotel, this photograph shows the Macdonald building. The alley entrance to the Riverside Amusement Park was immediately to the west of this structure. Also visible in this photograph is the Dog House, which served corn on the cob, hot dogs, and hamburgers to the strolling public. (Photograph by and courtesy of Will Citta.)

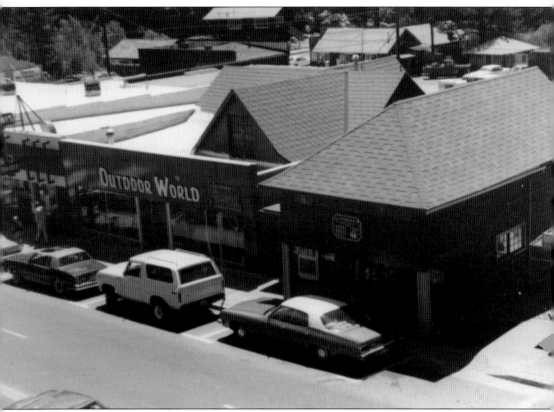

Farther east of the Macdonald building, this image captures another piece of the Dog House. The main floor of the Macdonald home was converted to a bookstore in 1928. Outdoor World opened in the 1960s to cater to participants of activities such as mountain climbing, hiking, and skiing. Though earlier visitors and residents had enjoyed being outside, many preferred to ride horses or view the wonders of Rocky Mountain National Park from touring cars and buses. (Courtesy of Will Citta.)

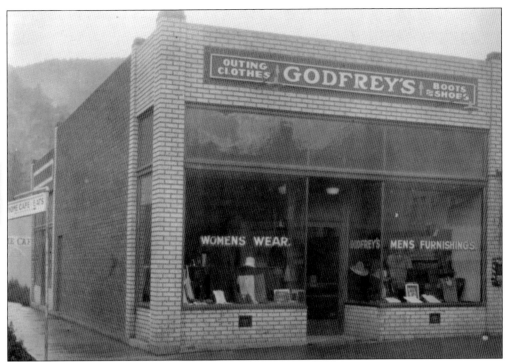

D. F. and Lora Godfrey operated this clothing store on the corner of Elkhorn Avenue and Riverside Drive. This was the end unit of a construction project known as the Boyd Building, which replaced the Boyd family home. (Photograph by Fred Clatworthy; courtesy of Estes Park Museum.)

After the Lawn Lake dam failure, the Boyd building was rehabilitated and many longtime businesses including Estes Park Hardware and Alpine Pharmacy were displaced. (Photograph by and courtesy of Will Citta.)

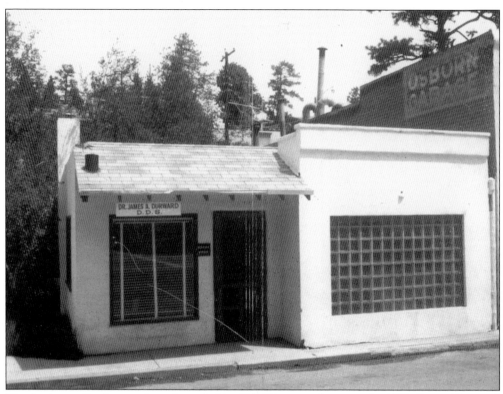

The business district was long bounded by Fall River on the west. In 1970, James Durward purchased a dental practice on the north side of Elkhorn Avenue, next to the former Osborn Garage. (Courtesy of Estes Park Museum.)

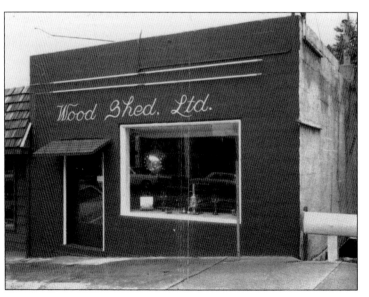

Across the street from Dr. Durward, the Wood Shed offered fine gifts from a building next to the Fall River. This business was established by Ralph Pettit in the 1950s and was later known as the Peacock, Ltd. (Courtesy of Estes Park Museum.)

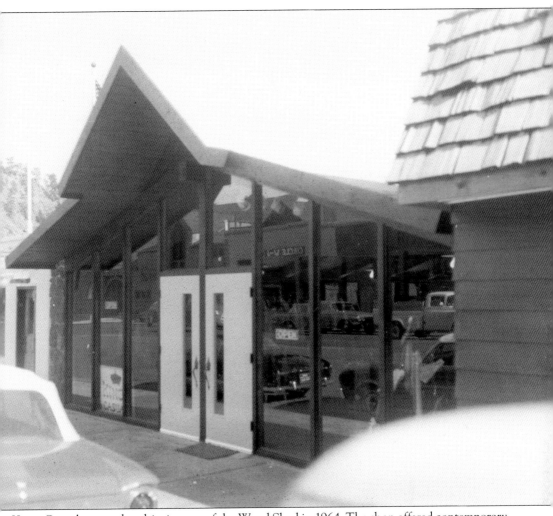

Kings Casuals opened at this site east of the Wood Shed in 1964. The shop offered contemporary women's clothing and "resort wear." At the rear was a back patio where husbands could relax and enjoy the music of Fall River while their wives tried on clothes. (Courtesy of Estes Park Museum.)

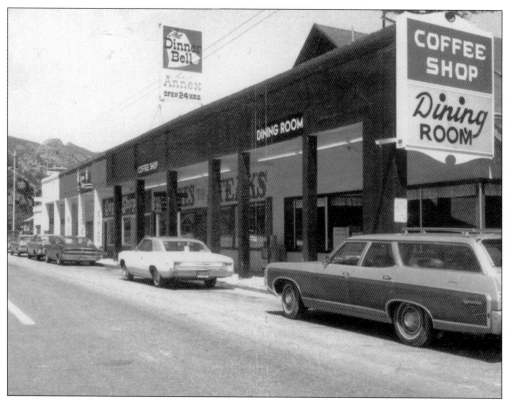

By 1959, the Osborn Garage had been converted into a restaurant and shops. The Dinner Bell was open 24 hours a day during the summer season, making it a popular stop for the late-night crowd. (Courtesy of Estes Park Museum.)

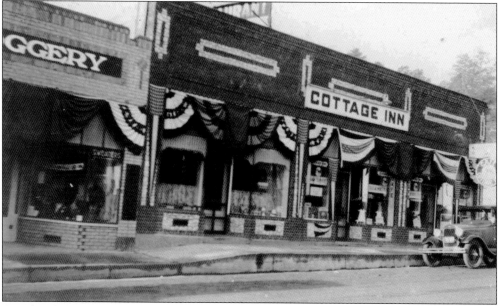

Another favorite restaurant on the west end was the Cottage Inn. It was later a family-style cafeteria owned by David Hart. (Courtesy of Byron Hall.)

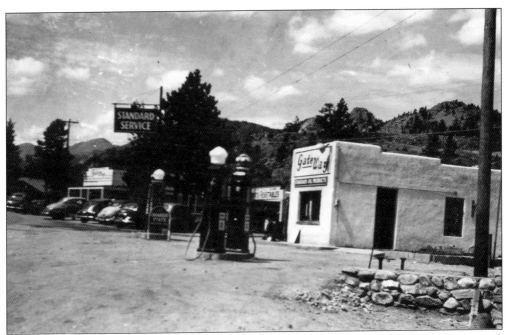

As more and more people began to vacation in private cars, the need for filling stations increased. This Standard station was at the west end of Elkhorn Avenue. (Courtesy of Byron Hall.)

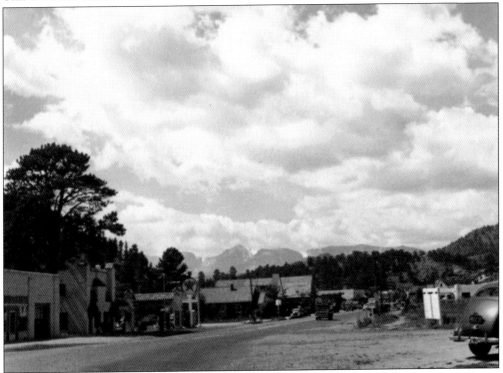

At about the same time, the east end of Elkhorn Avenue was anchored by a Texaco station at Trouthaven. Another Texaco sign is visible on the opposite side of the street. (Courtesy of Estes Park Museum.)

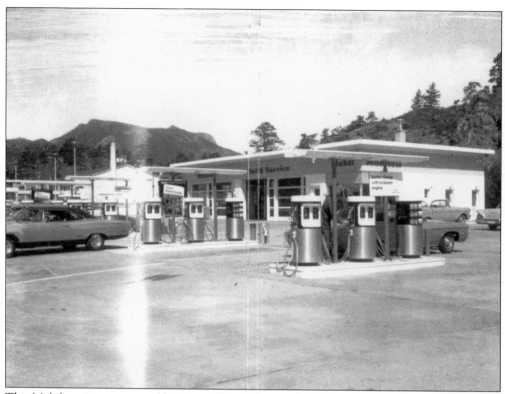

This Mobil station was owned by Mayor Harry Tregent. In 1969, it was one of six filling stations in downtown. (Courtesy of Estes Park Museum.)

This Amoco station on the west end of Elkhorn Avenue was built on the site of a livery stable. (Photograph by and courtesy of Will Citta.)

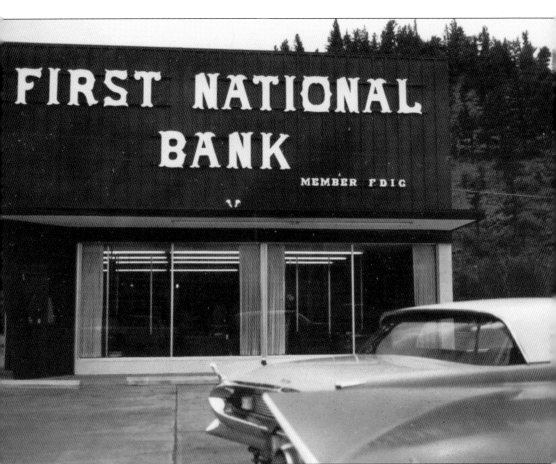

The first financial institution was the Estes Park Bank, established in 1908 by F. O. Stanley. By 1965, the town had grown enough to support a new bank. The First National Bank was financed by a group of Nebraska residents. This photograph shows its location on Elkhorn Avenue. It would eventually move to a site further north on MacGregor Avenue. (Courtesy of Estes Park Museum.)

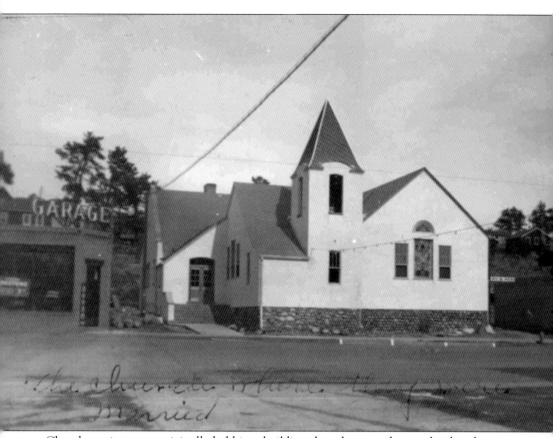

Church services were originally held in a building that also served as a school and community center. Funds were raised to construct the Community Church of the Rockies on West Elkhorn. Members of all denominations were welcome. (Courtesy of Byron Hall.)

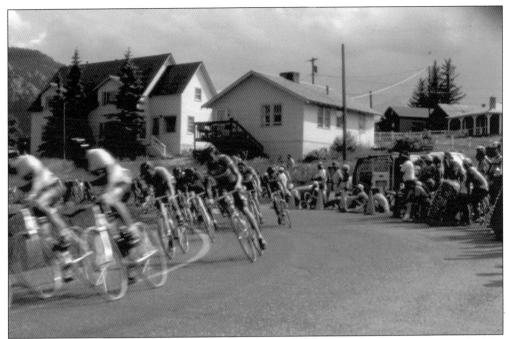

The larger building in the background is the site of the first Catholic church. It was called St. Walter's in honor of a son of the family who offered space in their home for worship. (Photograph by Mike Vogel; courtesy of Estes Park Museum.)

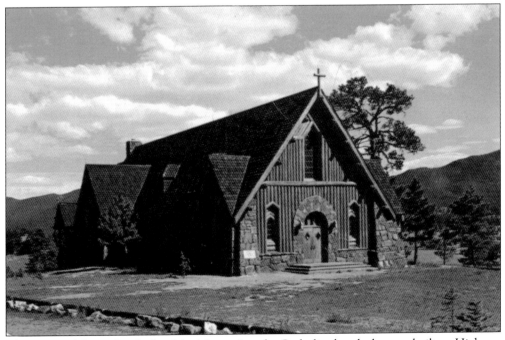

This postcard shows Our Lady of the Mountains, the Catholic church that was built on Highway 34 in the late 1940s. (Courtesy of Lulie and Jack Melton.)

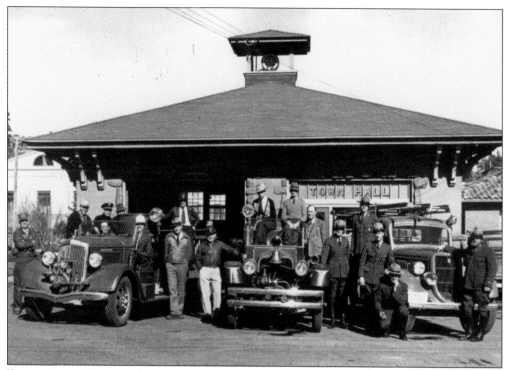

Fire protection was provided by volunteers. This photograph shows a new fire engine purchased by the town of Estes Park as well as representatives from Rocky Mountain National Park on their own fire engine. (Courtesy of Estes Park Museum.)

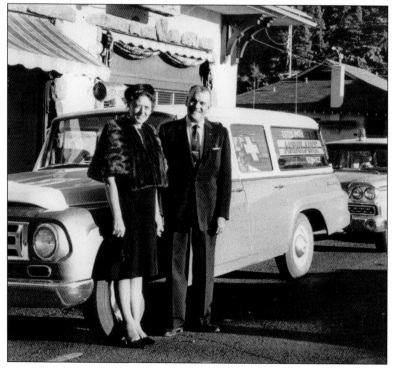

Local realtor Claire Noyes was instrumental in generating funding for an ambulance service. (Courtesy of Estes Park Museum.)

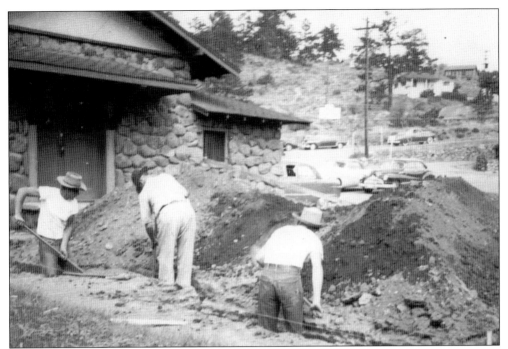

In the late 1920s, the business people of Estes Park organized a chamber of commerce to promote tourism. The town contributed a building site in Bond Park and Elizabeth Foot provided the funding for a permanent office and visitor center space. This 1950 photograph shows the beginnings of construction. (Courtesy of Estes Park Museum.)

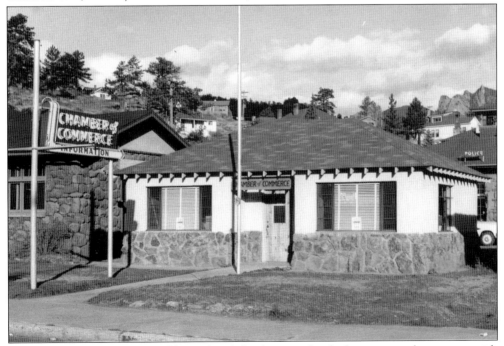

The chamber of commerce building echoed the design style of other municipal structures with river rock exteriors. This building was razed in 1976. (Courtesy of Estes Park Museum.)

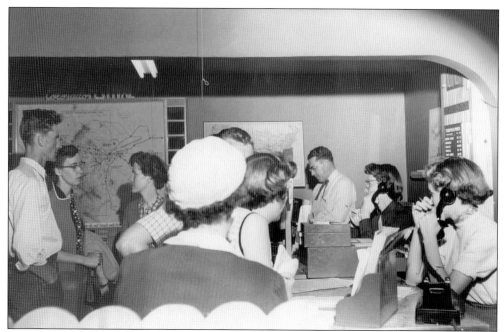

This photograph of the interior of the chamber of commerce shows Fred Clatworthy Jr. and his staff helping visitors. (Courtesy of Estes Park Museum.)

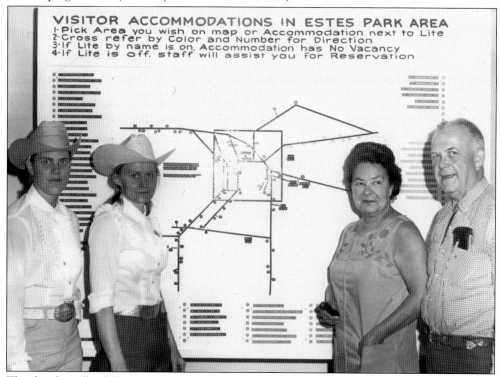

The chamber offered this interactive map to orient information seekers to available accommodations. Second from the left is Helen Justin, owner of the Lazy B Chuckwagon. On the far right is Ned Linegar, chamber manager in the 1960s. (Courtesy of Estes Park Museum.)

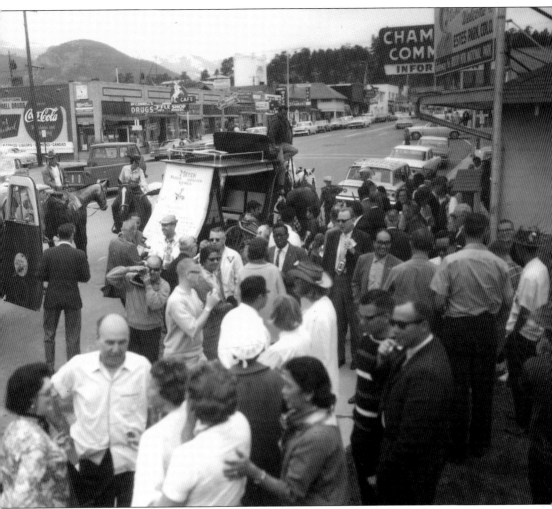

This photograph of a busy day in downtown shows a "fam" or "familiarization" tour whose participants may have been representatives of the Colorado Tourist Board or other travel professionals. They arrived from Denver on the bus barely visible on the left. In keeping with the western image of the town, they are meeting a rodeo queen and will be offered a ride in a stagecoach. (Courtesy of Lula W. Dorsey Museum, YMCA of the Rockies.)

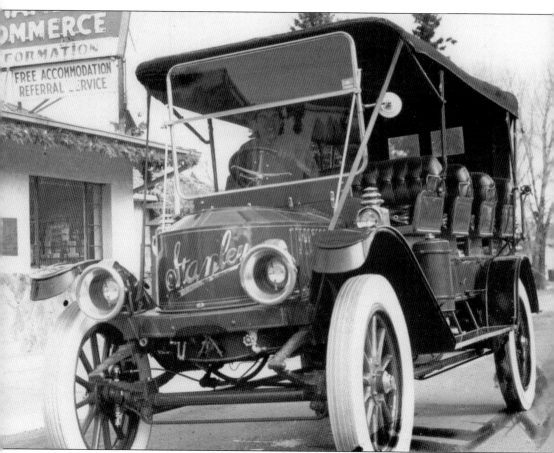

The Stanley mountain wagon was the original vehicle of choice for public transportation. This photograph is from the 1960s. (Courtesy of Estes Park Museum.)

Four

ARTS AND ENTERTAINMENT

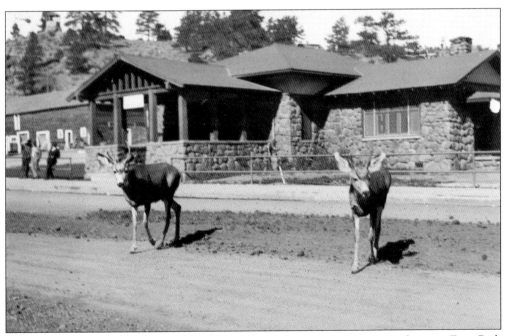

Native Americans, Joel Estes, the Earl of Dunraven, and countless others were drawn to Estes Park by the abundance of wildlife. In this 1931 photograph, mule deer stroll across Elkhorn Avenue. (Courtesy of Estes Park Museum.)

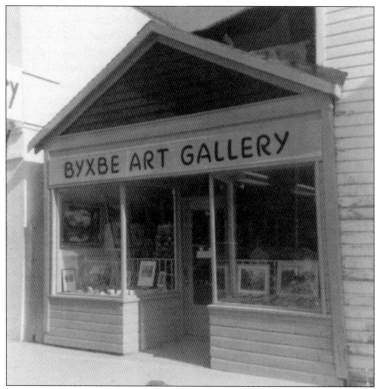

Among the many artists drawn to the beauty of Estes Park was Lyman Byxbe. This nationally recognized etcher and printmaker moved here in 1931. His artistic output also included oil paintings and hand-tinted photographs. He moved his business to this Elkhorn Avenue location in 1952. (Courtesy of Estes Park Museum.)

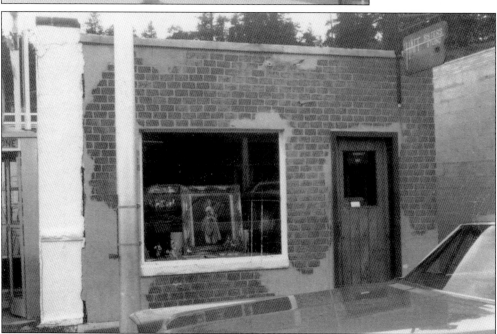

Marna and Roberta Haff were the daughters of a sculptor, Vernon Vincent Haff. They operated art studios in Loveland and Estes Park, specializing in paintings of animals. For the horse show crowd, their original art was available on neckties. They were also accomplished portrait painters. This late 1960s photograph shows their shop on the west end of Elkhorn Avenue. (Courtesy of Estes Park Museum.)

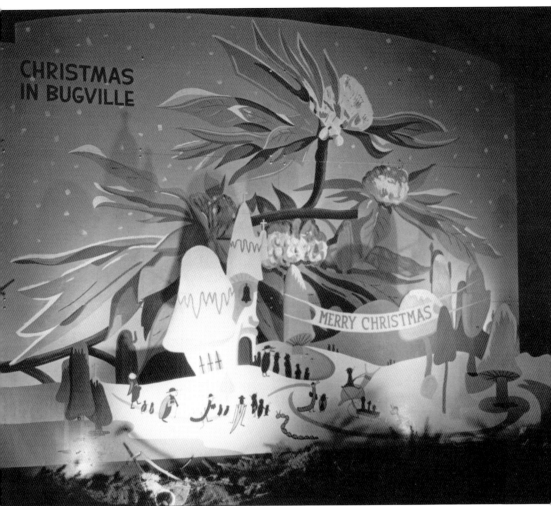

Buel Porter was an artist and sign painter. He contributed the unique holiday decorations that are still placed in Bond Park and other locations around town. They include a nativity scene, Santa's card workshop, wise men on their camels and shepherds with their sheep, and Santa in his sleigh with reindeer arriving on the knoll above the municipal parking lot. This scene of how insects celebrate Christmas is possibly the most unique. (Courtesy of Estes Park Museum.)

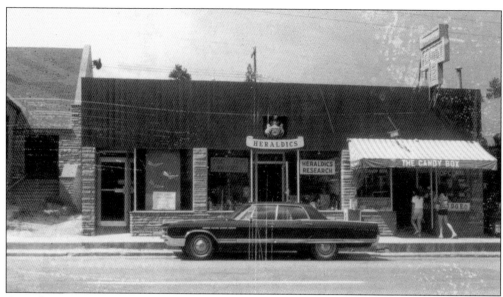

Genealogy researchers started a craze for finding a coat of arms. This 1969 photograph shows the Heraldics Research shop on west Elkhorn Avenue. (Courtesy of Estes Park Museum.)

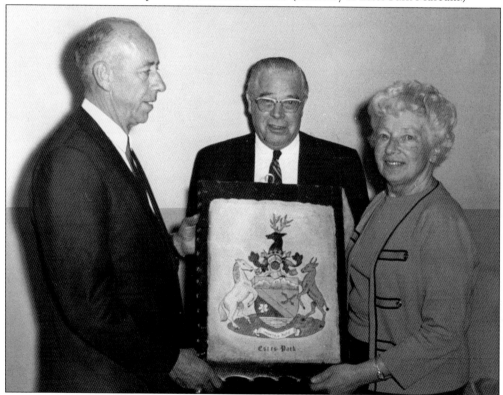

This 1967 photograph shows Mayor Ron Brodie accepting the Estes Park coat of arms at a chamber of commerce banquet. It includes a bighorn sheep and an elk, to represent the connection with wildlife, and a horse to acknowledge the many horse shows and the Western heritage of the town. (Courtesy of Estes Park Museum.)

This photograph from the 1960s shows the last livery stable on the edge of downtown. Otis Whiteside and his family earlier rented horses to the public from a location on the eastern slopes of Little Prospect. The Stanley Hotel is visible in the left rear behind Silver Lane Stables. (Courtesy of Estes Park Museum.)

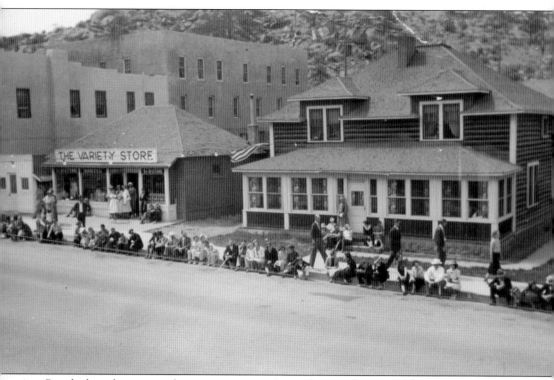

Parades have been a popular summer activity for residents and visitors alike. This 1938 photograph shows a crowd waiting for the action to begin. The large house was built by Sam Service in 1906. The National Park Hotel is visible on the far left. (Courtesy of Estes Park Museum.)

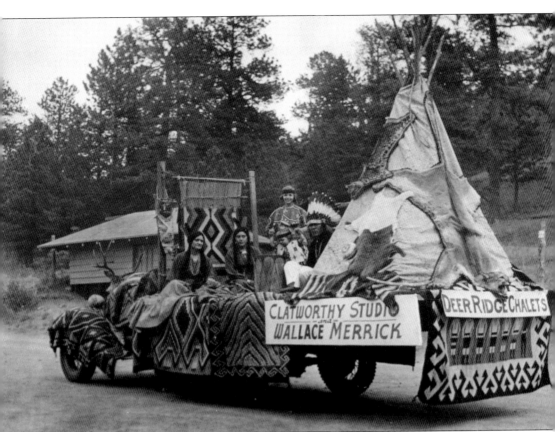

Parade entries reflected the history of the area. This photograph shows a family group of Native Americans. The Navajo rugs that decorate the float were possibly collected by Fred Payne Clatworthy on one or more of his trips through the Southwest. The front of the truck is adorned with a deer head. (Courtesy of Lula W. Dorsey Museum, YMCA of the Rockies.)

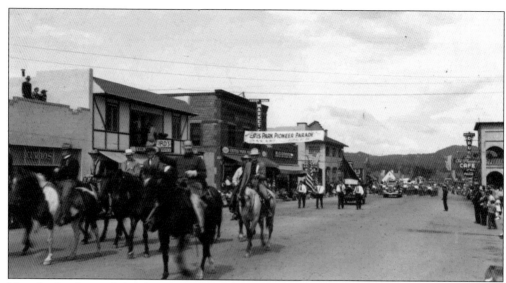

Horseback riders and the American flag were staples of any parade. (Courtesy of Byron Hall.)

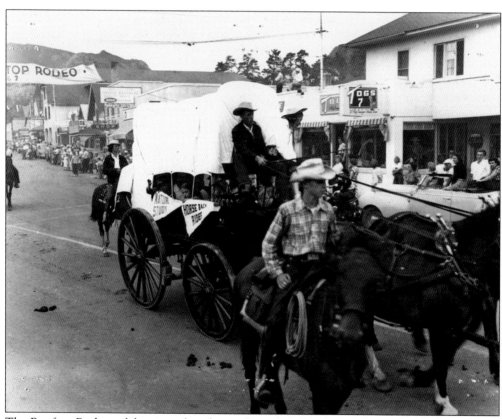

The Rooftop Rodeo celebration often featured two parades during the week of its run, which was traditionally the last week in July. (Courtesy of Lula W. Dorsey Museum, YMCA of the Rockies.)

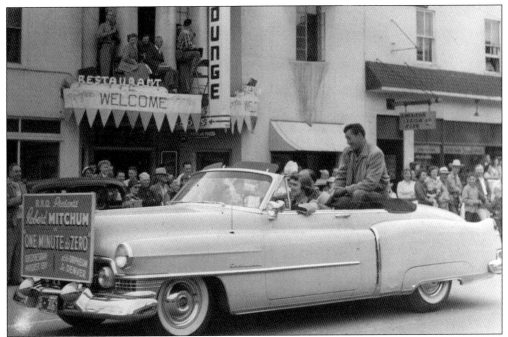

Movie stars were often recruited to visit for events, such as the annual opening of Trail Ridge Road, or to serve as grand marshals for the rodeo parades. This 1952 photograph features Robert Mitchum passing the Chez Jay. (Courtesy of Lula W. Dorsey Museum, YMCA of the Rockies.)

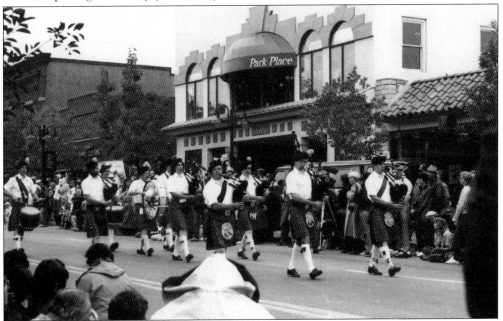

Estes Park had traditionally been a summer resort. Many businesses closed after Labor Day. In the 1970s, a group of young merchants brainstormed ideas for activities that would extend the season. The Longs Peak Scottish Highland Festival was launched as a September event. The moving force behind this celebration of heritage and its parade was Dr. James Durward. (Photograph by and courtesy of Will Citta.)

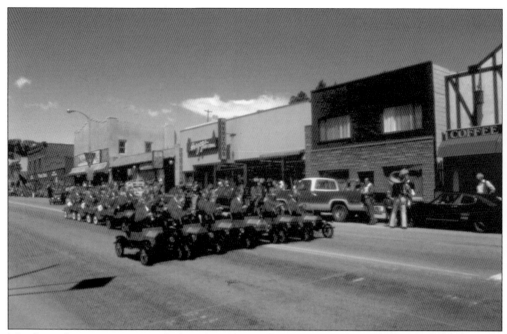

Members of various groups, including the Shriners shown in this 1983 photograph, were frequent participants in Estes Park parades. Herzog's Gift Corral replaced the Service home in the 1950s. (Courtesy of Estes Park Museum.)

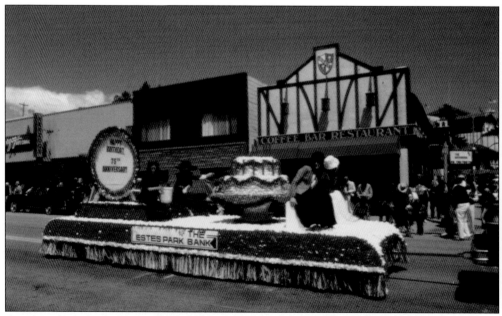

Another photograph from a 1983 parade celebrating the 50th anniversary of the completion of Trail Ridge Road shows employees of the Estes Park Bank celebrating an anniversary of their own. (Courtesy of Estes Park Museum.)

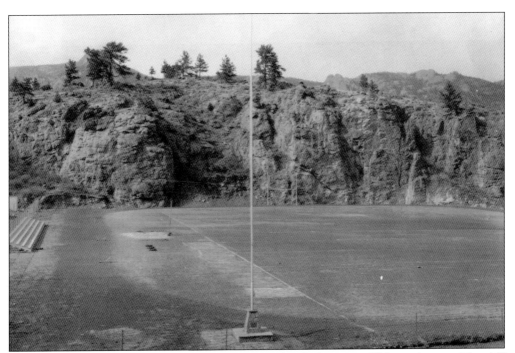

This early photograph of the football field shows the knoll above east Elkhorn Avenue. The cliff served as a natural backstop for field goals kicked through the uprights, though the ball often had to be rescued from Black Canyon Creek. (Courtesy of Estes Park Museum.)

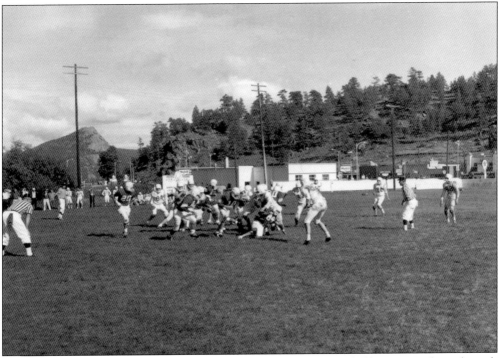

Saturday afternoon football games on the downtown field were attended by most residents through the early 1960s. (Courtesy of Estes Park Museum.)

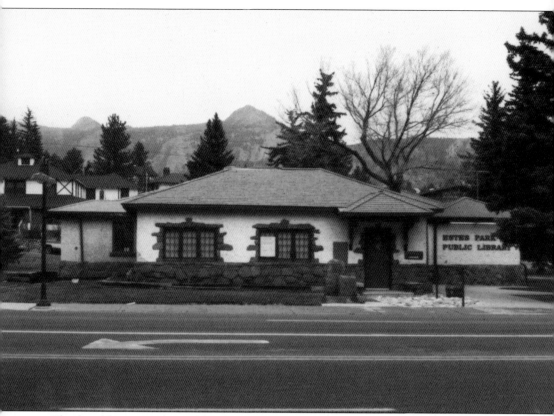

The first library was started by the Woman's Club and was housed in a room in the school. The town donated space in Bond Park for this stone and stucco building, which opened in 1922. This photograph shows the structure with several additions in about 1980. (Courtesy of Estes Park Museum.)

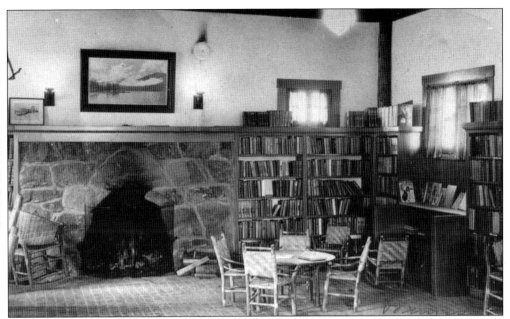

Many visitors and residents had connections to universities, and many workers were college students. Reading was a favorite activity for rainy afternoons or evenings. This photograph shows the interior of the 1935 addition financed by Eleanor Hondius. (Courtesy of Lula W. Dorsey Museum, YMCA of the Rockies.)

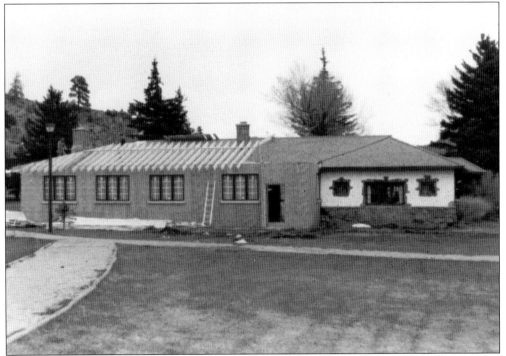

The size of the library more than doubled in 1978 with the addition of a "Colorado Room" to the western side. The original building, shown to the right of this photograph, housed the children's room. (Courtesy of Estes Park Museum.)

This photograph shows town employees working on replacing sod in Bond Park. In addition to being the site for the annual Woman's Club book and bake sale, the park is a popular gathering spot and site for festival events. (Courtesy of Estes Park Museum.)

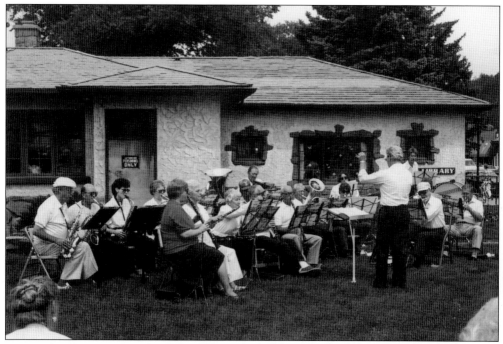

Estes Park offers a variety of opportunities to participate in cultural activities. This incarnation of the Village Band performs west of the library under the direction of Gary Elting. (Photograph by and courtesy of Will Citta.)

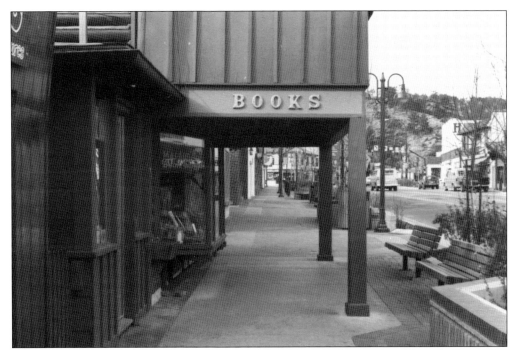

A mainstay of the cultural scene in downtown Estes Park is the Macdonald Book Shop. This family operation offers newspapers, magazines, and a selection of new books for all ages. Jessica Macdonald started selling books from the front room of her home in 1928. Her daughter Louise Brown took over in 1957, and her granddaughter Paula Brown Laing Steige is the current owner. (Photograph by and courtesy of Will Citta.)

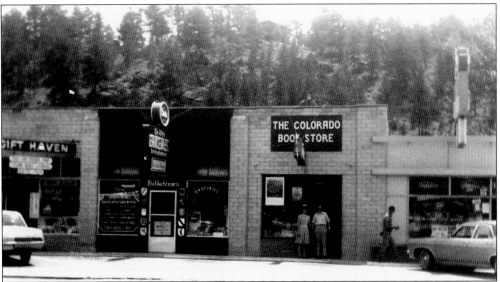

Books are also a popular souvenir, especially books about hiking, history, and scenery. Betty and Art Anderson opened the Colorado Book Store at the east end of Elkhorn Avenue in 1971. This row of shops was originally built as part of the Trouthaven complex. Also shown are Gift Haven, owned by Lois and Ted Matthews; the Die Alte Delicatessen, owned by the Marsh family; and the Jolly Jug liquor store. (Courtesy of Art Anderson.)

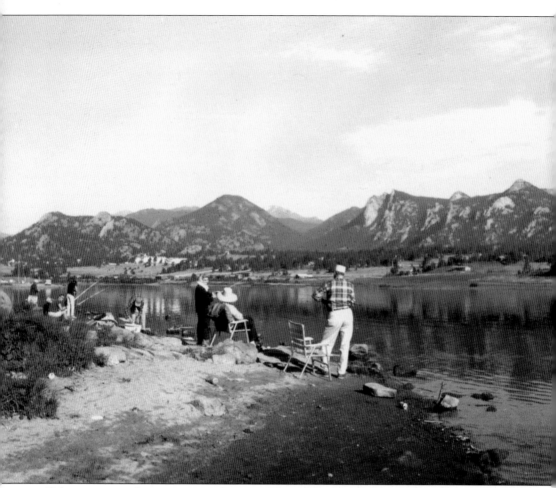

Fishing is a popular way to pass the time. This 1975 photograph of Lake Estes also shows the Stanley Hotel in the background. (Courtesy of Estes Park Museum.)

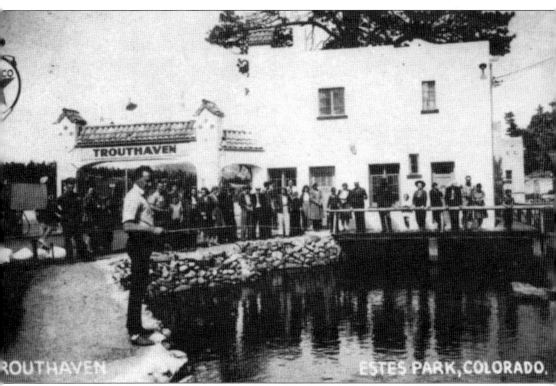

ROUTHAVEN ESTES PARK, COLORADO.

Gordon Hutchings had a dream, and it was realized in 1933 with the creation of Trouthaven. Several ponds held trout of various sizes. There was no need for a license, and equipment was furnished. Visitors flocked to the attraction to catch the fish and have them cooked by local restaurants for a nominal fee. Some of the trout were sold directly to local restaurants and hotel dining rooms. Many people found entertainment in watching the fishermen. The employees were college students from Fort Collins. They monitored the fishing activities and worked at the adjacent filling station. (Courtesy of Estes Park Museum.)

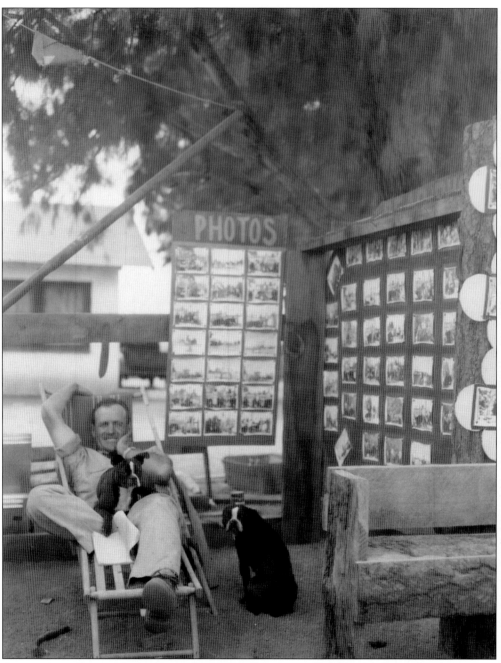

Among the college students who worked at Trouthaven was Phil Martin. One of his dreams was to offer a miniature train ride as an amusement. Another of his ventures was to offer photographs of visitors participating in staged activities. In this photograph from the late 1940s, Phil is shown relaxing with his dogs. (Courtesy of Estes Park Museum.)

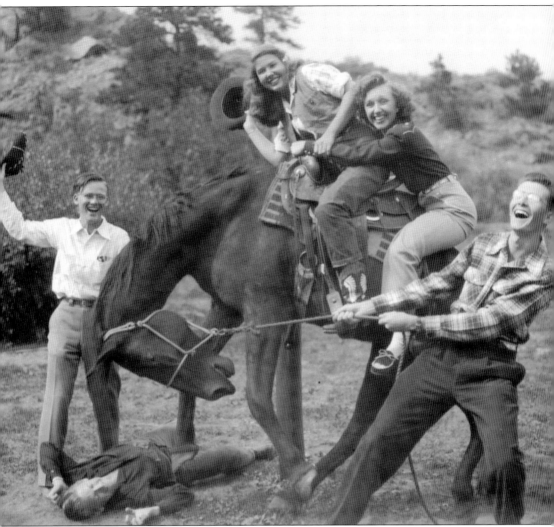

This picture shows young people enjoying themselves on one of Phil Martin's photographic props. In the plaid shirt at the far right is Louis Moore, and sliding off the horse to his right is Elizabeth Dorsey. (Courtesy of Estes Park Museum.)

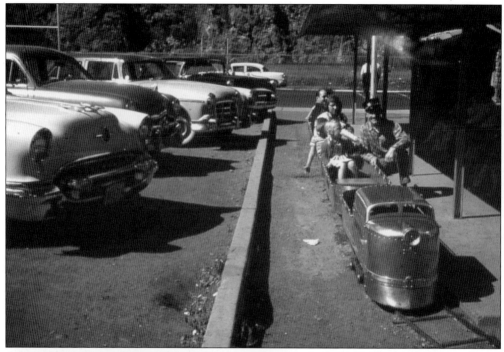

In 1950, Phil "Casey" Martin moved his Silver Streak railroad from the north side of Elkhorn Avenue to the Trouthaven property. He charmed children with a chant that mentioned "bumblebee knees" as a delicacy offered in the dining car and enumerated the route through "Storybook Land." There were squeals of delight when he used a crowbar to push a car up into the air and proclaimed, "There's a bear under there!" (Courtesy of Lulie and Jack Melton.)

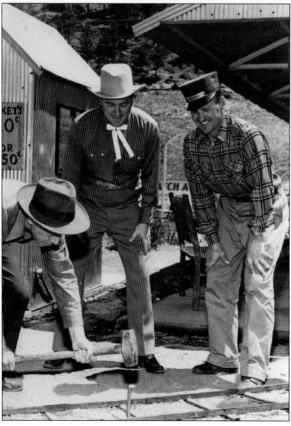

Mayor Ron Brodie drives the golden spike to celebrate the Silver Streak railroad's contribution to the happiness of visitors to Estes Park. (Courtesy of Lulie and Jack Melton.)

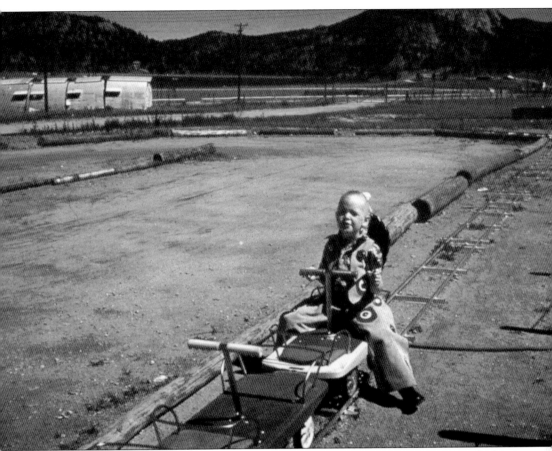

Other attractions included miniature golf courses and driving ranges. Louis Kinman, a popular big band leader, created an amusement park called Louie-Ville on the South Street Vrain Highway. One of the attractions was flatbed cars operated by pump action. In this 1957 photograph, Lulabeth Cox is enjoying a ride. The screen for the Lake Estes Drive-In Theater is visible at the far left. The grandstand at Stanley Park is at the far right. (Courtesy of Lulie and Jack Melton.)

Frank Bond opened the first movie theater in Estes Park. The Park Theater was sold to Ralph Gwynn, who made several improvements to the sound and projection quality. In 1926 he added this tower, which became the standard for building height and is still an easily recognized landmark. (Courtesy of Lula W. Dorsey Museum, YMCA of the Rockies.)

A second movie theater opened in a building that had been a warehouse and garage constructed by Sam Service. Originally called the Rustic, it was later renamed the Village. The structure also housed a popular barbershop. (Courtesy of Estes Park Museum.)

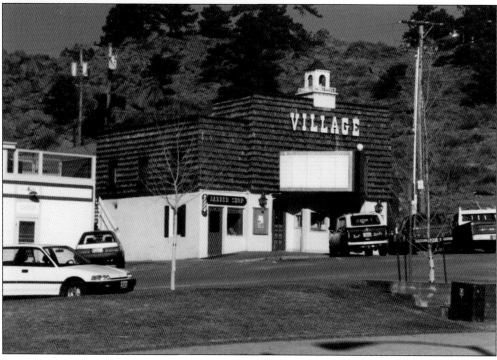

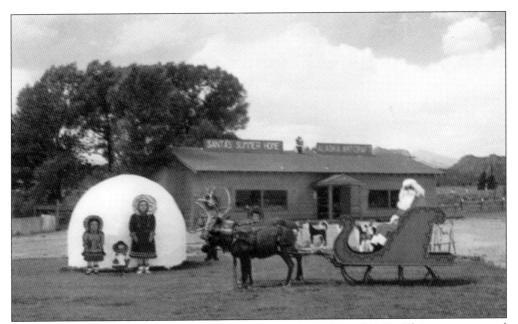

Santa's Summer Home was a popular stop for families in the 1950s and 1960s. The owners assumed that Santa had Eskimos for neighbors. Visitors could see live caribou and sled dogs. Christmas ornaments were among the souvenirs for sale. (Courtesy of Lulie and Jack Melton.)

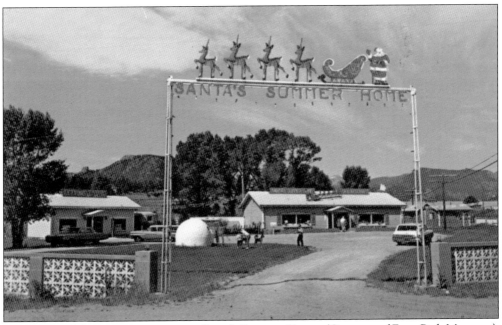

This postcard shows improvements to Santa's Summer Home. (Courtesy of Estes Park Museum.)

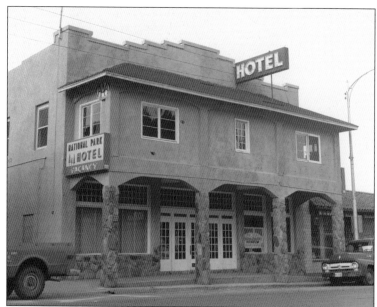

By the 1970s, the demand for hotel rooms was decreasing, as families preferred to stay in motels or cabins with kitchen facilities. The National Park Hotel was closed after almost 50 years in business. (Courtesy of Estes Park Museum.)

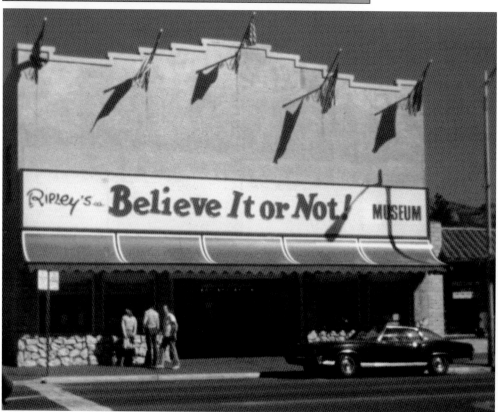

Ripley's Believe It or Not! Museum was developed from a popular newspaper feature that showcased strange and unusual facts about people and places. Visitors could see a variety of displays. At one time, there were many similar attractions in town, including a space museum, a movie museum, and automobile museums. (Photograph by and courtesy of Will Citta.)

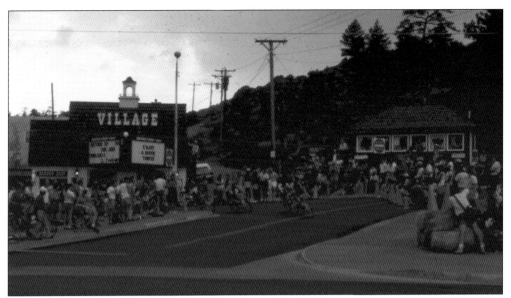

The Celestial Seasonings tea company created the Red Zinger bicycle race in 1975 as a way to promote awareness of alternative means of transportation. The first races were held in Boulder. As the race gained popularity, stages were added, including one set in Estes Park. The event later evolved into the Coors Classic and provided an opportunity to see Olympic athletes in action. This 1983 photograph by Mike Vogel shows a crowd watching racers taking a tight turn. (Courtesy of Estes Park Museum.)

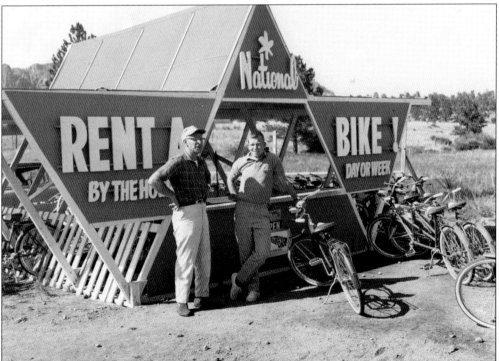

Estes Park had been promoting bicycle transportation since the 1960s. (Courtesy of Estes Park Museum.)

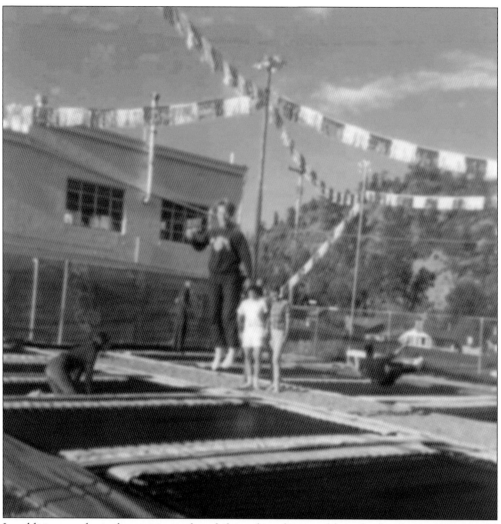

In addition to physical activities such as hiking, bicycling, and horseback riding, visitors could bounce their way to fitness at the trampoline center in 1966. (Courtesy of Lula W. Dorsey Museum, YMCA of the Rockies.)

Five

FIRES, FLOODS, AND WEATHER

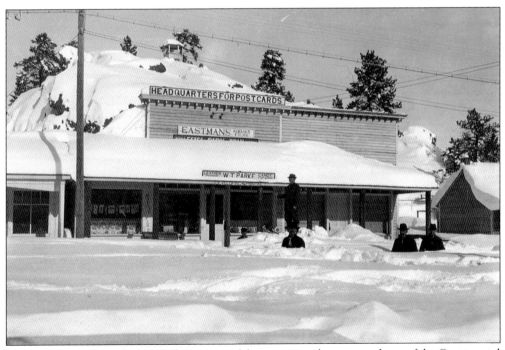

Many winter storms in Colorado dump most of their snow on the western slopes of the Continental Divide, and others blow out to the eastern plains, but when it does snow in Estes Park it can get deep. A major blizzard occurred in 1913. This photograph may show the reason that W. T. Parke sold his business in April 1921. (Courtesy of Estes Park Museum.)

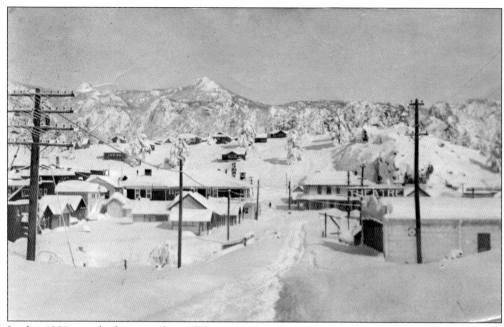

In this 1920 view looking north to Elkhorn Avenue from Moraine Avenue, all activity has been brought to a halt. (Courtesy of Estes Park Museum.)

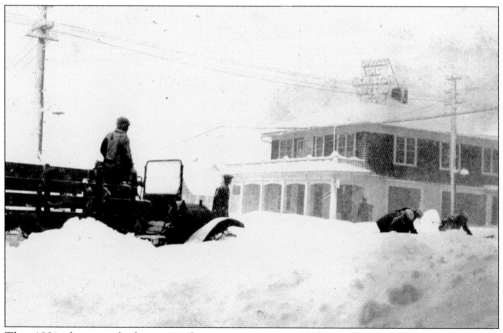

This 1921 photograph shows another storm clogging Elkhorn Avenue. (Courtesy of Estes Park Museum.)

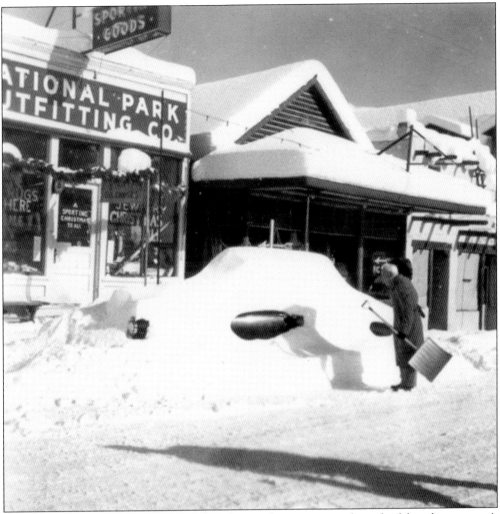

By 1949, advances had been made in street plowing, but sometimes the task of shoveling out one's car seemed daunting. (Courtesy of Estes Park Museum.)

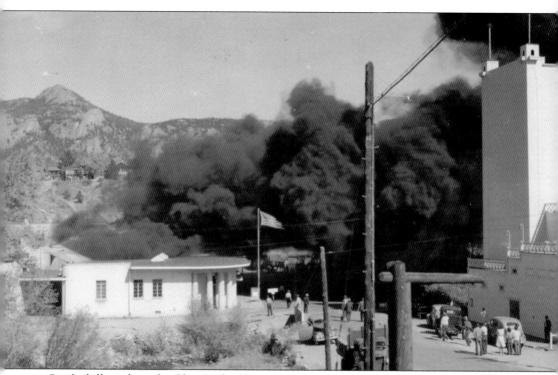

Smoke billows from the Chez Jay building. Jessie Jay opened a cocktail lounge and dining room in addition to hotel rooms in July 1937. It was called the "Shangri-La of the Rockies," because the design elements were based on the popular movie *Lost Horizon*. The main entrance to Chez Jay was on Elkhorn Avenue. The post office was located in the space fronting on Moraine Avenue. (Courtesy of Estes Park Museum.)

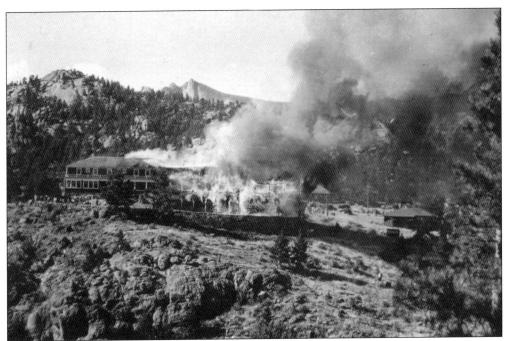

One of the largest fires in Estes Park history started in the attic of the Lewiston Hotel on September 4, 1941. Attempts to save the building were hampered by its location, which offered no access from the south or west. (Courtesy of Lula W. Dorsey Museum, YMCA of the Rockies.)

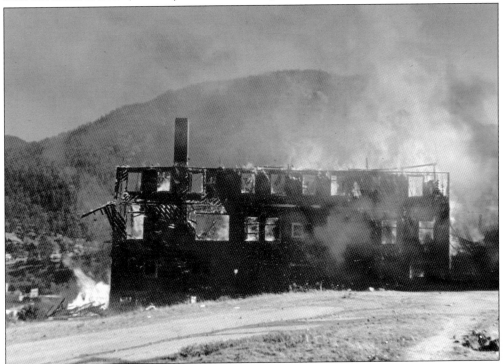

Most personal belongings and some of the Lewiston furnishings were saved, and no one was injured. (Courtesy of Estes Park Museum.)

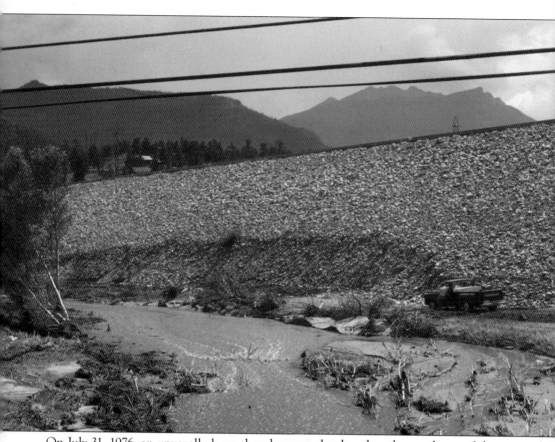

On July 31, 1976, an unusually large thunderstorm developed to the northeast of the town of Estes Park. Residents were used to afternoon rains, but this one started early and continued on into the evening. Twelve inches of rain fell in approximately four hours. The Big Thompson River rose steadily and started to overflow its banks as a flash flood. Down Devils Gulch Road, the community of Glen Haven was devastated by floodwaters. When the North Fork and the Big Thompson joined at Drake, a 20 foot wall of water started crashing eastward, destroying homes, cars, and lives. Initial reports were that the Lake Estes Dam had broken, causing the largest natural disaster in Colorado history. This photograph by P. W. Schmidt shows how the dam was scoured, but not breached, by floodwaters from the (usually) Dry Gulch. (Courtesy U.S. Geological Survey Photographic Library.)

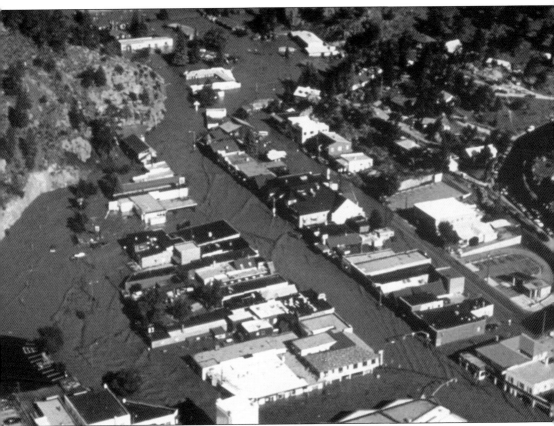

The Big Thompson Flood was called a "hundred year event," so residents of Estes Park were surprised when less than 10 years later, on July 15, 1982, an earthen dam broke in Rocky Mountain National Park. Millions of gallons of water were released from the 48-acre lake, surging down a mountainside before spreading out in Horseshoe Park and inexorably sweeping eastward. By the time the flood reached the western edge of town, the leading edge was between 3 to 5 feet of muddy water. This photograph by R. D. Jarrett shows the block west of the intersection of Elkhorn and Moraine Avenues. (Courtesy U.S. Geological Survey Photographic Library.)

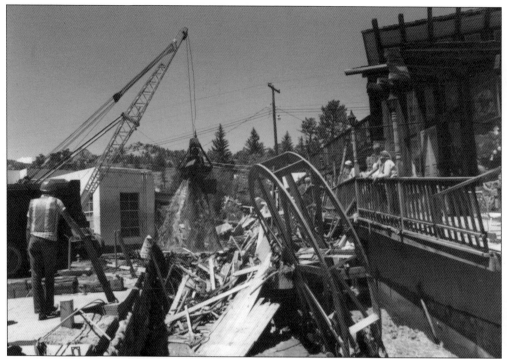

Water from Lawn Lake and Cascade Lake followed the general course of Fall River along Highway 34. Here a crew lifts the water wheel, which had been a major feature of Dr. Durward's development on west Elkhorn Avenue. (Courtesy of Lulie and Jack Melton.)

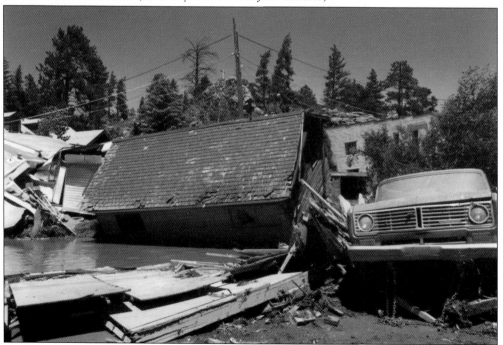

Debris from destroyed mobile homes and vehicles pushed along by the floodwaters clogs up Cleave Street. (Courtesy of Lulie and Jack Melton.)

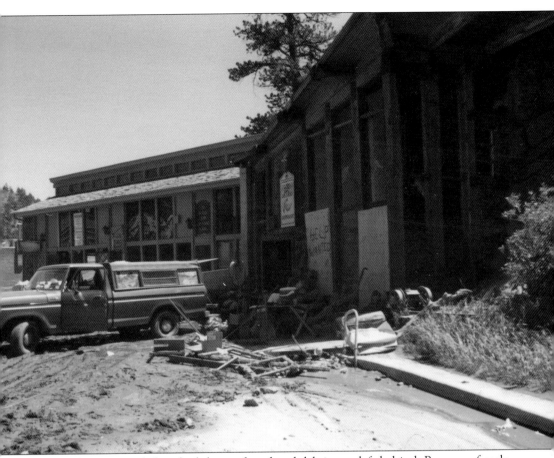

As the floodwaters receded, a thick layer of mud and debris was left behind. Because of early warnings, the downtown had been evacuated. Many people watched from high points and were available to offer immediate help to business owners. (Courtesy of Lulie and Jack Melton.)

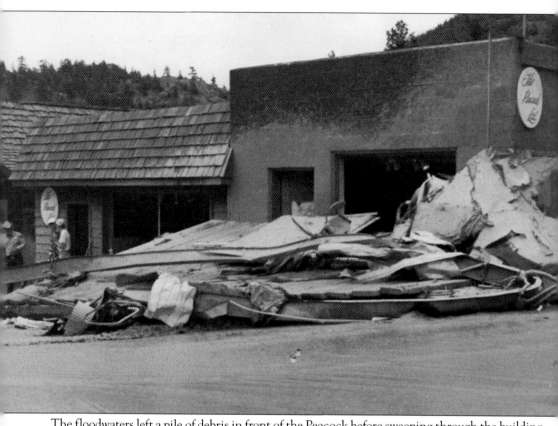

The floodwaters left a pile of debris in front of the Peacock before sweeping through the building. (Courtesy of Ann Morrow.)

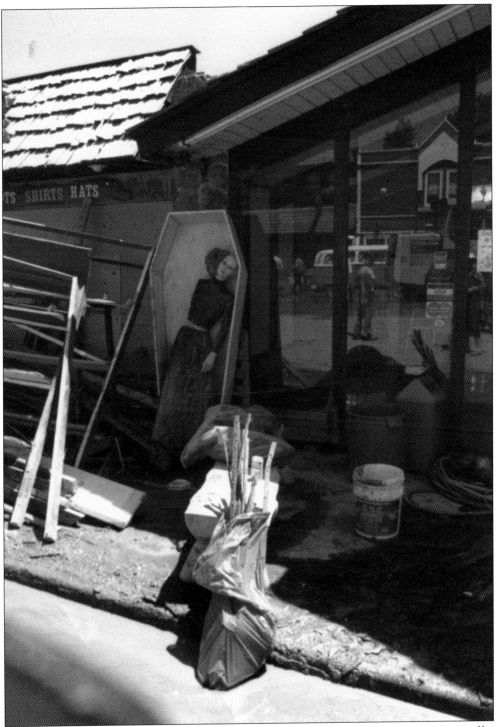

The owners of Kings Casuals demonstrated a sense of humor by placing a mannequin in a coffin in front of their devastated store. (Courtesy of Lulie and Jack Melton.)

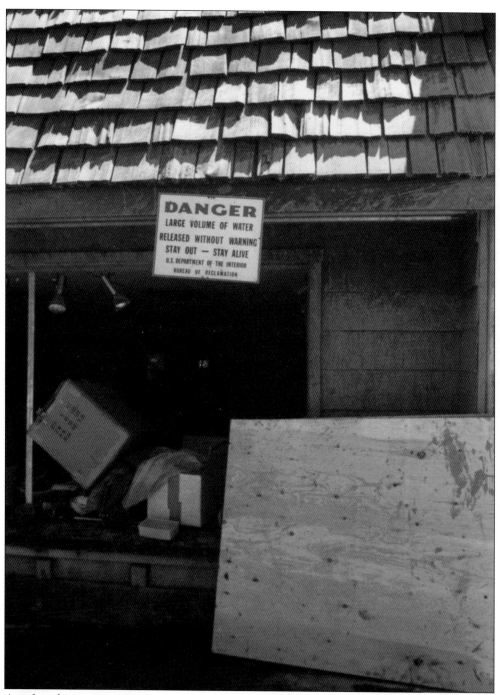

DANGER
LARGE VOLUME OF WATER
RELEASED WITHOUT WARNING
STAY OUT — STAY ALIVE
U.S. DEPARTMENT OF THE INTERIOR
BUREAU OF RECLAMATION

Another shop owner posted a sign that would normally be found at Marys Lake or the Adams Tunnel. Businesses on the south side of the street sustained heavy damage. The Estes Park Public Library and the Estes Park Area Historical Museum ultimately produced a slide show of the flooding, "Flood: the Lawn Lake Dam Break and Estes Park Flood of July 15, 1982," which included photographs taken by the library director Ted Schmidt and staff members of the *Estes Park Trail Gazette*. (Courtesy of Lulie and Jack Melton.)

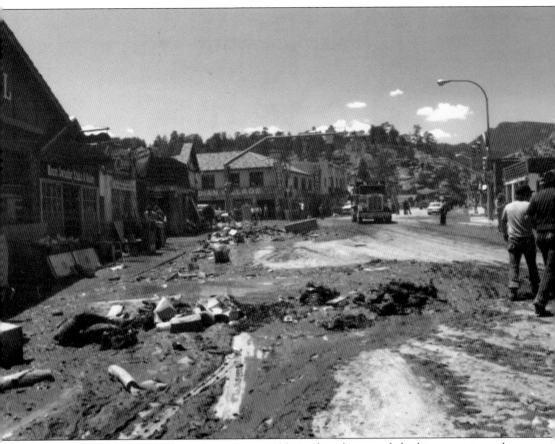

Various kinds of debris and the thick mud are visible in this photograph looking west towards the intersection of Elkhorn and Moraine Avenues. The dam break occurred about 6:00 a.m. on a sunny morning, and the water was through downtown before 10:00 a.m. (Courtesy of Lulie and Jack Melton.)

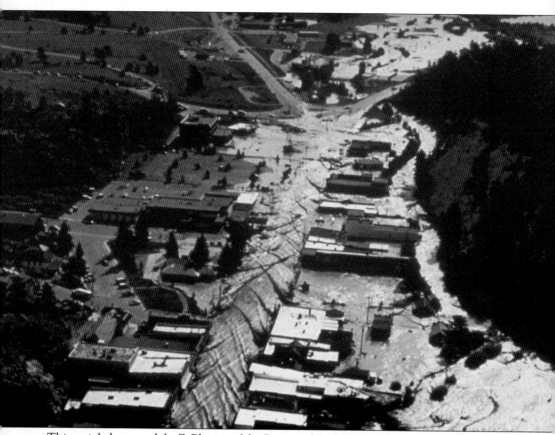

This aerial photograph by Z. Bleuins of the Bureau of Reclamation shows the floodwaters sweeping past Bond Park and the municipal building towards the intersection of Highways 34 and 36. (Courtesy of U.S. Geological Survey Photographic Library.)

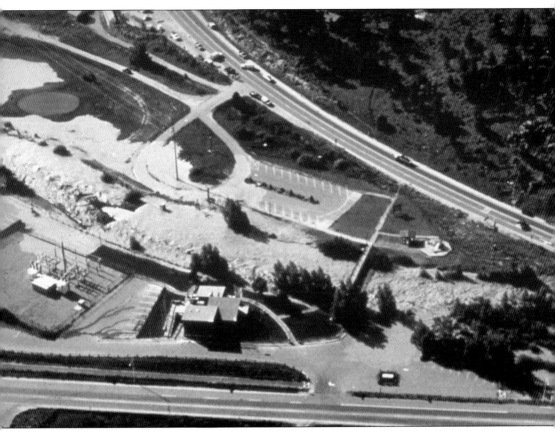

By the time the floodwaters passed the eastern edge of town, they were mostly back in the river channel. This photograph by Z. Bleuins of the Bureau of Reclamation shows the Estes Park Area Chamber of Commerce and Visitor Center and the Estes Park sanitation plant on Highway 34. (Courtesy of U.S. Geological Survey Photographic Library.)

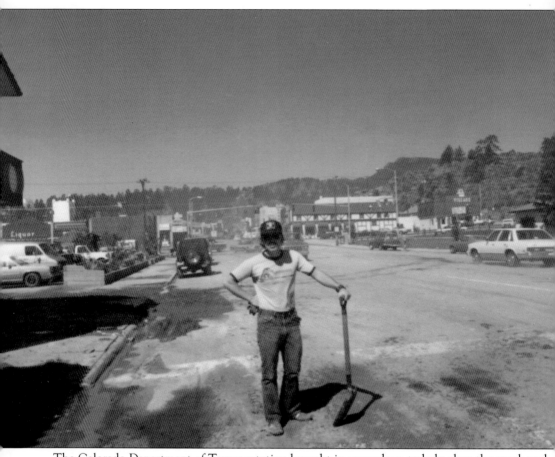

The Colorado Department of Transportation brought in snowplows to help clear the muck and debris from the street. Every available resident and many visitors helped in the cleanup, which took approximately 10 days. In this photograph, Jack Melton takes a break from shoveling out La Casa. (Courtesy of Lulie and Jack Melton.)

BIBLIOGRAPHY

Anderson, E. R. A *History of Trouthaven, Estes Park Colorado*. Estes Park, CO: self-published, 2007.

Cassell, Colleen Estes. *The Golden Pioneer: Biography of Joel Estes, the Man who Discovered Estes Park*. Seattle, WA: Peanut Butter Publishing, 1999.

Frank, James R., and R. Paul Firnhaber. *Magic in the Mountains: Estes Park, Colorado*. Estes Park, CO: Our Natural Heritage Publishing, 2007.

Jessen, Kenneth. *Estes Park: A Quick History Including Rocky Mountain National Park*. Fort Collins, CO: First Light Publishing, 1996.

Jessen, Kenneth. *Rocky Mountain National Park: Pictorial History*. Loveland, CO: J. V. Publications, 2008.

Melton, Jack R., and Lulabeth Melton. *YMCA of the Rockies: Reflections, Traditions, and Vision*. Estes Park, CO: YMCA of the Rockies, 2006.

Pickering, James H. *"This Blue Hollow": Estes Park, the Early Years, 1859–1915*. Niwot, CO: University Press of Colorado, 1999.

Pickering, James H. *America's Switzerland: Estes Park and Rocky Mountain National Park, the Growth Years*. Boulder: University Press of Colorado, 2005.

Ramsey, Jane, and Marty Yochum Casey. *Early Estes Park Artists, 1870–1970*. Estes Park, CO: Alpenaire Publishing Inc., 2005.

Robertson, Janet. *The Magnificent Mountain Women: Adventures in the Colorado Rockies*. Lincoln, NE: University of Nebraska Press, 1990.

www.arcadiapublishing.com

Discover books about the town where you grew up, the cities where your friends and families live, the town where your parents met, or even that retirement spot you've been dreaming about. Our Web site provides history lovers with exclusive deals, advanced notification about new titles, e-mail alerts of author events, and much more.

MADE IN THE USA

Arcadia Publishing, the leading local history publisher in the United States, is committed to making history accessible and meaningful through publishing books that celebrate and preserve the heritage of America's people and places. Consistent with our mission to preserve history on a local level, this book was printed in South Carolina on American-made paper and manufactured entirely in the United States.

This book carries the accredited Forest Stewardship Council (FSC) label and is printed on 100 percent FSC-certified paper. Products carrying the FSC label are independently certified to assure consumers that they come from forests that are managed to meet the social, economic, and ecological needs of present and future generations.

FSC
Mixed Sources
Product group from well-managed forests and other controlled sources

Cert no. SW-COC-001530
www.fsc.org
© 1996 Forest Stewardship Council

Find Your Place in History.